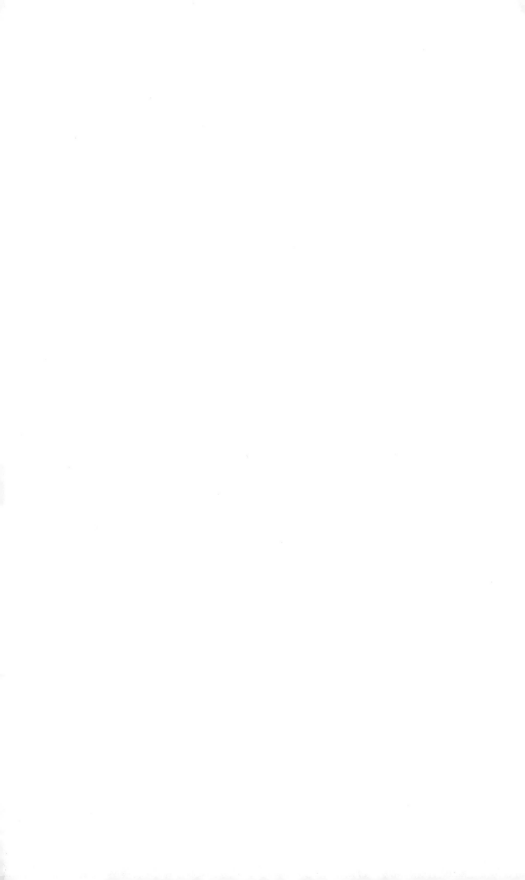

RESPONSES TO **Rembrandt**

Also by Anthony Bailey

RESPONSES TO
Rembrandt

ANTHONY BAILEY

[t] *Timken Publishers*

Timken Publishers, Inc., 225 Lafayette Street,
New York, NY 10012

Portions of this work were originally published in
The New Yorker.

LIBRARY OF CONGRESS
CATALOGING-IN-PUBLICATION DATA

Bailey, Anthony.
 Responses to Rembrandt / Anthony Bailey.
 p. cm.
 Includes bibliographical references (p. 131) and index.
 ISBN 0-943221-18-8 : $24.95
 1. Rembrandt Harmenszoon van Rijn, 1606–1669.
Polish rider. 2. Painting, Dutch—Attribution. 3. Painting,
Dutch—Expertising. 4. Painting, Dutch—
Historiography. 5. Rembrandt Harmenszoon van Rijn,
1606–1669—Criticism and interpretation.
 I. Rembrandt Harmenszoon van Rijn, 1606–1669.
 II. Title.
 ND653.R4A73 1993
 759.9492—dc20 93-15042
 CIP

Designed by David Bullen
Copyedited by Anna Jardine
Composition by Wilsted & Taylor
Printed in the United States of America

To Eloise Spaeth

Acknowledgments

I am grateful to Claudia Swan for her help, and for her knowledge of Dutch and familiarity with the ways of art history. My thanks are also due to *The New Yorker*, in which a large part of this essay first appeared, and particularly to Robert Gottlieb, Adam Gopnik, and Amy Clyde.

Contents

Contents

"To compleat our ideas of the masters it is necessary to take in their whole lives, and to observe their several variations so far as we possibly can. . . . The mischief is, men are apt to confine their ideas of the master to so much only as they know, or have conceived of him; so that when any thing appears different from this, they attribute it to some other, or pronounce it not of him."

JONATHAN RICHARDSON, "ESSAY ON THE ART OF CRITICISM," 1773

"Rembrandt sait que la chair est de la boue dont la lumière fait de l'or."

PAUL VALÉRY, *DEGAS, DANSE, DESSIN*, 1946

Foreword

This book attempts to examine some of the basic questions of art history and the appreciation of works of art by way of a particular artist, Rembrandt van Rijn, and a particular painting, *The Polish Rider*—a work that some experts currently suggest is not by Rembrandt. It presents this drama of threatened deattribution in the context of the history of Rembrandt scholarship and the development of "connoisseurship." It grapples with several thorny aspects of the connoisseur's profession, among them the claims of some practitioners to scientific accuracy and the belief of others that an experienced eye and a well-honed instinct provide more reliable guides. I have tried to describe some of the elements that make the craft of attribution a fascinating and uncertain process and—for those who care about the monetary value of art—make the ownership of poorly documented paintings an exciting gamble. These elements include the habits of scholars, the ambitions of collectors and dealers, and the ways of museums and their officials, as well as our present knowledge and igno-

rance of how (and what) a great master created in seventeenth-century Holland. The world of art scholarship is in some respects a hermetic one, in which expert speaks to expert. Amateurs of painting may well feel excluded by arcane terminology, intimidating expertise, and a sense that many of the scholars aren't prepared to share with them the intricacies of investigation and argument.[1] I have been interested in the Netherlands and its most famous artist for thirty-five years, and have expressed this interest in three books and numerous articles. But more recently I have felt the need to explore the particular world of art scholarship as it relates to Rembrandt, in order to illuminate the intricacies and bring forth the arguments as best I can, and along the way, perhaps, cast some light on a great painter and an intriguing painting. Not the least of Rembrandt's attractions for many people is how approachable his work is; one of the charms that draws viewers to *The Polish Rider* is its mystery. If there are tensions in this paradox, I hope they are fruitful. I would like to examine the mystery without dispelling its magic. I would like to enhance the approachability without suggesting that I think I have written the last word about Rembrandt.

RESPONSES TO
Rembrandt

A Young Man on Horseback

AT FIRST glance, the brown-gold light in the sky could be either dawn or twilight. It glows most brightly over the left-hand ridge of a rugged hillside, whose summit is dominated by a domed citadel. Under this ridge, a stream tumbles down the dark flank of the hill (ill. 1). In equally deep shade to the right, the square tower of what looks like a church can be made out standing above a pool, the red glimmer of a campfire, and what may be the faint figures of several people, keeping warm or keeping watch. In the immediate foreground a horse steps quickly along a track from left to right; it is seen somewhat from below, so that with its rider it bulks large against the hill. The horse is pale, spectral, maybe almost on its last legs, yet with an eager lift to the nose, eyes gazing straight ahead, its progress emphasized by a fly switch of horsehair flowing back under its neck toward the right boot of its rider. The young man in the saddle looks out into the distance (ill. 2), with the light falling on his right shoulder and on the elbow he holds out so proudly. He wears what appears to be mili-

tary uniform: buff boots (right heel tipped down behind the stirrup), vermilion breeches, long-skirted quilted yellow-gray coat (gold-braided along the line of buttons which fasten to the neck), and fur-trimmed cap with a vermilion cloth crown. He looks to be in his early twenties, with broad cheeks, strong nose, full lips, wide chin. Whatever the anxieties of his mission, he gives an impression of being inwardly warmed by the knowledge that his existence is charmed. He has no traveling gear except a leopard skin under the saddle but is otherwise as well armed as a seventeenth-century light horseman might be. On his left side, away from us, hangs a bow; the straight hilt of one of his two swords is to be seen on that side, too; the second, a saber, with curved hilt and scabbard, is suspended along the near flank of the horse, under the rider's right knee. In his left hand the young man holds the red leather reins, and in his right—knuckles turned under, wrist hard against his waist—a war hammer. Its long, thin stock lies across a black leather quiver crammed full of arrows.

Let us step back. The soft cord, stretched between brass posts, that surrounds carpet and furniture in the center of the long gallery of the Frick Collection touches the backs of our legs. The portraits on either side come into view: both very black, by Hals. The wall is covered with green fabric. The velvety green carpet has been brushed by sweepers or feet into patterns, and suggests a calm sea ruffled by cat's paws. Gray winter light is filtered down from the skylight. Under the bottom edge of the frame that holds the young man on horseback is another horse, nicely placed: a small bronze sixteenth-century Paduan statuette, headed in the same direction, but cantering. It stands on an elaborately carved chest, roughly coffin-size. From this distance, certain elements in the painting (which is about four feet high and four and a half feet wide) work differently. The hilly background becomes a high, undulating dark blur. The light in the sky is reflected from five main areas, harmoniously highlit—the right side of the young man's face; his right upper arm and elbow; the horse's right flank; the young man's right coat skirt and leg; and the right side of the horse's neck and head. The vermilion of the young man's hat and breeches is echoed in the less vivid red of the reins. Horse and rider have a determined momentum, seeming to walk out of darkness into light just before walking into darkness again. If we step forward once more we see a small

plaque affixed to the frame which gives the Frick accession number for the painting, the name of the artist, and the traditional name of the picture: 98. REMBRANDT. POLISH RIDER.

For me, this is an occasion to say to myself, "Still unchanged!" In 1984, Josua Bruyn, the chairman of the Rembrandt Research Project, a team of art scholars working on a multivolume definitive catalogue, or corpus, of paintings by Rembrandt, suggested—in a book review of another scholar's work—that this painting, "the so-called '*Polish Rider*,'" as Bruyn referred to it, was by a little-known pupil or follower of Rembrandt, Willem Drost, and not by the Master himself.[1] From the earnest pages of the art history journal *Oud Holland*, the shock waves rippled worldwide, and gradually reached other art historians, museum curators, dealers, auctioneers, collectors, artists, and all the others interested in Rembrandt. The first reaction of many was probably not unlike that of Arthur Wheelock, the curator of northern Baroque painting at the National Gallery of Art, Washington, D.C., and an expert in many aspects of Dutch seventeenth-century art. "I was stopped in my tracks," says Wheelock.[2]

The Polish Rider came to its place on a gallery wall in Henry Clay Frick's Fifth Avenue mansion after a stay of more than a century in Poland. (I will continue to call the painting by its traditional name.) No record of the painting has been found from before 1791.[3] In that year, Michal Kazimierz Ogiński, the grand hetman of Lithuania, who was or had recently been on a trip to Holland, offered it to the last king of Poland, his cousin by marriage. It has been supposed that Ogiński bought the painting in Holland, but it is possible that he acquired it from other members of the Ogiński family, two of whose forebears had studied in the Low Countries in the seventeenth century. In 1791, Ogiński wrote to King Stanislaus Augustus II:

> Sire,
> I am sending Your Majesty a Cossack, whom Reinbrand had set on his horse. This horse has eaten during his stay with me 420 German gulden. Your Majesty's justice and generosity allow me to expect that orange trees will flower in the same proportion.[4]

Presumably, Ogiński received 420 guldens' worth of orange trees from the royal conservatory in exchange for the *Cosaque à Cheval*—the name under which the painting shortly afterward appeared in the king's collection. However, Stanislaus did not last long on the throne (he died in St. Petersburg in 1798), and the *Cosaque* passed into other hands. It belonged to Countess Thérèse Tyszkiewicz, to Prince F. K. Drucki-Lubecki, to Count H. Stroynowski (who was also the bishop of Wilno), and, later, to his niece Valerie Stroynowska, who married Count Jan Amor Tarnowski. It was hanging in the Tarnowski castle at Dzików in Galicia when scholars from western Europe apparently first heard of it. The painting made a trip to Vienna and back in 1877, possibly for restoration or for testing of its sale value. Abraham Bredius, the eminent art historian and director of the Mauritshuis, in The Hague, visited Dzików in 1897, traveling by slow local trains, and the painting—"the fine cavalier," Bredius called it—came west for an exhibition of Rembrandt paintings in Amsterdam a year later.[5] By then, the *Cosaque à Cheval* seems to have been adopted by the Poles as one of their own and had begun to be referred to as *The Polish Rider*.

In April 1910, the English writer, painter, and art critic Roger Fry, who was occasionally employed as a picture buyer by wealthy American collectors, wrote to his mother:

> I am very busy just now. I have to go to Poland to buy for Mr. Frick a very important picture.... The owner is a rather stupid country gentleman who insists on selling the picture in his château, and that's why I have to go and get it, as I must see it before buying. The picture costs £60,000 so it is an important affair.... It's tiresome and hateful work but I couldn't refuse to do it.... At all events I ought to be handsomely paid for it, and indeed it comes at a critical time for I am just at the end of my resources.[6]

Osbert Sitwell later recalled hearing Fry describe how he had arrived in a remote castle, full of second-rate French furniture and 1880s objets d'art, and had felt it impossible any real work of art could exist in such surroundings. Then: "Suddenly, a cord was pulled, a curtain was rolled back, and there, before his eyes, was revealed one of the world's masterpieces of painting."[7]

There followed an exchange of telegrams among Fry and Frick and Knoedler, the Paris art dealer, one of which read:

KNOEDLER. PARIS. HAVE CABLED FRY TO LET YOU HAVE PICTURE AND HAVE YOU SECURE NEW FRAME. QUITE RIGHT AWFULLY LONELY. FINE WEATHER AND GOLF. FRICK.[8]

Frick's draft on the Morgan bank was for $293,162.50, which may have included a commission for Fry on top of the £60,000 for Count Tarnowski. The painting was publicly exhibited in London on its way to New York, and a copy made for the count by the portrait painter Ambrose McEvoy. (In 1927, there was a serious fire in the Dzików castle, and the copy was lost.) In 1971, Miss Elizabeth Carroll, of 29 Teignmouth Road, London, wrote a letter to the editor of the London *Times* about the sale of *The Polish Rider* to Mr. Frick by her grandfather Count Tarnowski. "For this 'crime,' he was recently, 35 years after his death, made the subject of most violent public attacks in Warsaw's Communist press by the curator of the Polish National Museum, Dr. Lorenz, who wrote that my grandfather should for this action be put on the nation's 'Black List.'"[9] Dr. Lorenz, it seems, hadn't considered the likelihood that *The Polish Rider* would have been burned to cinders if Count Tarnowski hadn't sold it to Mr. Frick.

Until the doubts of Josua Bruyn, of the Rembrandt Research Project, appeared in *Oud Holland*, only one art scholar had disagreed in print with the traditional attribution of *The Polish Rider* to Rembrandt. This was Alfred von Wurzbach, who in 1906, in the first volume of his lexicon of Netherlandish painters, ascribed the painting to Aert de Gelder, the artist who was perhaps Rembrandt's last pupil.[10] Numerous books about Rembrandt have included an illustration of *The Polish Rider*. Indeed, until Bruyn, most Rembrandt experts would have happily gone along with the words of Julius Held, professor emeritus of art history at Barnard College, Columbia University, whose extensive iconographic study of *The Polish Rider* first appeared in 1944: "Its fragmentary signature, consisting of an R on a rock at the right, if genuine, proves only what need not be proved, Rembrandt's authorship."[11]

The Rembrandt Research Project

T HE MEMBERS of the Rembrandt Research Project are the sort of scholars who do not take much for granted; doubt is fundamental to their enterprise.[1] Five remain of the seven scholars who constituted the team in 1968—all Dutch, all men, all art historians. The two who have died are J. A. Emmens and J. G. van Gelder. Two current members, S. H. Levie and P. J. J. van Thiel, are respectively director general and curator of paintings at the Rijksmuseum, Amsterdam, and in recent years their museum responsibilities have made them less active in the Project. The three other members are Bob Haak, former head of the Amsterdam Historical Museum; Josua Bruyn, professor emeritus of art history at the University of Amsterdam; and Ernst van de Wetering, who, in his early fifties, is the youngest, and who served as a junior researcher before becoming a full member of the team.

Haak is the founding father of the RRP. Now in his mid-sixties, the author of a number of books, including a respected biography of Rem-

brandt and an extensive survey of Dutch seventeenth-century painting, he lives in an early-eighteenth-century house on the Prinsengracht, one of the old canals encircling the center of Amsterdam, and writes occasional pieces about art for a Dutch financial newspaper. Haak is exceptional among the scholars; he has no degree and no professional title. His hair is gray, cut short. His face is broad-cheeked and weathered—you could imagine him at the helm of a Dutch sailing barge. His first experience in the art world was practical, as assistant to an art dealer. "Mr. van Hoogendijk taught me how to look at paintings," Haak says of the dealer. "He showed me how to study a picture all over with a magnifying glass, and to look just as closely at the back of it." While at van Hoogendijk's, Haak read a great deal of art history, which helped him get his next job: as an assistant in the Department of Painting at the Rijksmuseum. In 1956, he took part in organizing a large exhibition for the 350th anniversary of Rembrandt's birth. "The paintings poured in, and we tried to put them in chronological order," he recounts. "I was faced with many paintings said to have been painted by Rembrandt at the same period, and it struck me that one man could not have created so many different sorts of pictures at one time. Many, surely, were not by Rembrandt."[2]

Although he may have felt like an iconoclast at that moment, Haak was having doubts others had had before. In 1792, a French art dealer named Lebrun warned that many paintings claimed as authentic Rembrandts were in fact by his pupils.[3] From early in the Master's career, students had copied his works; sometimes these paintings may have been touched up by Rembrandt. Dealers even in the seventeenth century may have added a Rembrandt signature to such works, and some scholars believe that Rembrandt may have done so, too. The practice was not unusual: Titian and Raphael, among others, signed their pupils' work.[4] Haak, in any event, shared his worries with a dealer friend, Dan Cevat, who told him, "You ought to do something about this. Otherwise it's chaos." Haak began to question the reigning experts. He talked to van Gelder and Bruyn, who agreed action was needed to redefine Rembrandt's oeuvre. Haak says, "Bruyn took charge. He is much cleverer than I am."

The aim of the Project, which Haak thus founded, was to establish for

Rembrandt an authentic body of work by conscientious examination and by such up-to-date scientific methods of investigation as dendro-chronology (to date wood used in panels), chemical analysis of pigments, and X-ray photography. In 1968, the Project was provided with funds for research, travel, substitute lecturers, and secretarial expenses by the Netherlands Organization for the Advancement of Pure Research. The team members, who were unsalaried, took time off from their jobs and looked at some six hundred paintings then considered to be Rembrandts. They went out in pairs to museums and private collections in different parts of the world, and they made thorough observations and wrote painstaking descriptions of the paintings. Generally, they had a friendly reception and were helped in their work. However, a few private collec-tors and smaller museums were suspicious of the team's intentions. Ac-cording to Haak, one owner didn't want to let the scholars see his paint-ing but changed his mind when he realized how serious they were. In several places, such as the Morehead Planetarium gallery at the Univer-sity of North Carolina, Chapel Hill, they were forced to examine a paint-ing on the wall, in a frame, even under glass. Sometimes they worked in dim light, or balancing on a ladder with a hand-held lantern, while being watched by curious members of the owner's family.

This examination period lasted five years, through 1972. Then the team began to sift the findings and bring in technical evidence. They usu-ally met for Friday lunch in an office they had been given in the Central Research Laboratory for Art and Science at the south end of the Museum-plein, a five-minute walk from the Rijksmuseum. On an easel in the room, as if monitoring the discussions, was an enlarged detail of the head and baleful eye of Rembrandt's Claudius Civilis. In his painting *The Revolt of the Batavians*, the artist had made the leader of the insurgent tribesmen against the Romans look like a bandit chief.

The chairman of the Rembrandt Research Project Foundation and ef-fective leader of the team for its first quarter-century has been Josua Bruyn. In his late sixties, born in Amsterdam, he is a tall man with a cour-teous, formal manner which could be that of a distinguished surgeon or judge. He did his doctoral dissertation on Jan van Eyck but, like many art

historians in Holland, found it impossible to avoid the seventeenth century. His chief aide on the RRP for some time has been Ernst van de Wetering, who now holds Bruyn's old professorial chair. Van de Wetering's admiration for Bruyn's stamina is great: "He has been the motor of the Project." But Bruyn has admitted that he did not realize at the start how much time and labor would be involved. "Fifteen years would have been all right," he says. "But twenty—and more than twenty! It has gone on too long."

It was not until 1982 that the team brought forth the first volume of its *Corpus of Rembrandt Paintings*. The book covered the period from 1625 to 1631, and had the appearance of a massive old-fashioned family Bible. Volume two, even larger, came out in 1986 and dealt with the years from 1631 to 1634. Volume three, taking us to 1642, the year of *The Night Watch*, appeared in 1990. With twenty-seven years of Rembrandt's career still to digest, and at least two more volumes needed to handle them, the team's work, presented in English for an international readership, will probably not be finished before the turn of the century. It is not known which of the volumes yet to come will embrace 1655, when *The Polish Rider* is thought to have been painted, and give the Project's verdict on the picture; it is probably at least five years away.

The two members of the RRP who studied *The Polish Rider* were Bob Haak and Josua Bruyn. The year was 1969. For the sake of economy and convenience, the team worked geographically rather than chronologically—in this case, looking at all the paintings in and around New York City that were attributed to Rembrandt, whether they were thought to be early, middle, or late works. Haak and Bruyn traveled thriftily; where they could they stayed with friends. They had only amateur photographic equipment and counted on museums and owners to provide detailed photographs. At the Frick, they were received hospitably and given access to facilities that ordinary visitors to the collection do not enjoy. They were allowed to work upstairs in the private rooms, with *The Polish Rider* and two other Rembrandts in the collection removed from their frames and placed on easels. The two men were able to eschew the customary mu-

seum formality, take their jackets off and spread their notes on the floor. They spent hours with the *Portrait of Nicolaes Ruts*, which Rembrandt painted in 1631; with *The Polish Rider*; and with the *Self-Portrait* of 1658 (ill. 3). William Suhr, the Frick's conservator, was on hand to answer questions about the condition of the pictures and about restoration that had been done. Recalling those days, Josua Bruyn says, "It was an experience to see a picture off the wall, out of the frame, and away from the slightly sanctifying atmosphere a gallery gives it. You could look at it in more of a vacuum. In such circumstances a lesser picture will lose much of its authority, with its weaknesses laid bare. A good picture may gain." (Haak had seen *The Polish Rider* on an earlier visit to New York and had already felt that it had weaknesses.) Not long after Haak and Bruyn returned to Amsterdam, the Frick helpfully sent Bruyn some twenty photographs he had requested of the three pictures; eleven were of *The Polish Rider* and included details of the horse's legs and head and the rider's head, and X rays of the horse's right forehoof.

Previous attempts to catalogue Rembrandt's oeuvre have been made by connoisseurs working on their own. An early contribution was that of John Smith, an English art dealer, who, without actually seeing many of the originals, in the 1830s accepted 614 paintings as authentic Rembrandts. In 1913, the Dutch scholar Cornelius Hofstede de Groot published a catalogue raising the figure to 988. The trend since has been downward. In 1923, John C. Van Dyke, a professor of art history at Rutgers College and something of a wild card in this business, did the most reductionist job on the Master to date, granting him only 48 paintings. A less radical oeuvre was that catalogued by the Dutch scholar Abraham Bredius in 1935, which accepted 630. Horst Gerson, also Dutch, in 1968 brought the total of accepted paintings down to 420. It looks as if the Rembrandt Research Project might reject between 100 and 150 of these.

A characteristic of many previous connoisseurs in this field of attribution has been to pick and choose without giving convincing reasons for their choices. Haak observes, "Gerson threw out many paintings but didn't say why." The *Corpus* of the RRP goes to the other extreme: it gives

thread counts of the warp and woof of canvases and includes dissertations on such subjects as the painting of lace or the value of Rembrandt signatures; details the provenance of pictures and provides long quotations from sale catalogues; and considers at length for each painting how the painter has approached the theme, handled the paint, and arrived at a color scheme. The paintings are arranged in three categories: category A comprises those paintings which are undoubtedly by Rembrandt; category B, those on which no absolute decision has been reached; and category C, those which the team concludes are not by the Master and which are therefore deattributed, disattributed, demoted, or rejected. The three volumes of the *Corpus* contain 144 A's, 12 B's (7 in volume one, 1 in volume two, and 4 in volume three), and 120 C's.

This severity of judgment reflects Josua Bruyn's intentions. The number of cases in which decisions about authenticity have been left open is "fairly small," the *Corpus* notes.[5] It continues: "This can be seen as an indication that there has been an urge to express firm opinions. In this respect, this book is in the tradition of oeuvre catalogues that present a solid body of accepted works and just as solid a body of rejected paintings, in a situation where in fact there is always room for discussion and reconsideration." This final statement is seen by some as disingenuous. The size, presentation, and gravitas of the *Corpus* appear to leave very little room. (The eminent British art journal *The Burlington Magazine* commented in an editorial generally welcoming volume one that the weighty tome was not good for reading in bed, particularly if the bed was shared with a partner.[6]) Yet the first volume was, for the most part, well received, the team's hard work admired, and little exception taken to its weeding out of Rembrandt's work of that period; indeed, a few experts wondered why the team had bothered to consider a number of paintings that were not seriously regarded as Rembrandts by most contemporary scholars of the subject. This criticism the RRP apparently took to heart: in the next volume the members announced they were shifting the basis of their work from Bredius's number to Gerson's smaller total of attributions. Despite this, the second volume was longer. Although there were signs in volume one that the team had a constrained view of Rembrandt that might arouse dis-

agreement, opposition took time to form. When it did, some critics expressed suspicion of the team's methodology; others proceeded from anxieties about individual paintings—on which the team was known or suspected to hold strong opinions—to concern for the team's overall judgment. Soon controversy seemed to be expanding much faster than the RRP's *Corpus*.

The Master's Reputation

REMBRANDT'S REPUTATION has never been so far-reaching as it is today. His name has become synonymous with the term "great artist"; in an episode of the television series *M*A*S*H*, for example, a wounded GI refers to his tattoo as having been done by "the Rembrandt of tattooists." Rembrandt's work appears, apparently because easily recognized, like Leonardo's Mona Lisa, in a 1988 British television commercial for a cereal, while in the United States, a recently developed "tooth-whitening system" has been given the name Rembrandt. In the Netherlands, the artist's name or illustrations of his paintings lend luster to trains, ships, city squares, restaurants, hotels, biscuits, and cigars. The Dutch Elisabeth Bas cigar was named after a well-known portrait in the Rijksmuseum. (Unfortunately, Abraham Bredius decided that the painting was not by Rembrandt but by his pupil Ferdinand Bol; other experts, though, think Rembrandt may have had a hand in it.) Homage to the Master is paid even in a club in Maastricht, where once a week the regulars dress up as the figures

in *The Night Watch* and, after a few drinks, take their positions in a *tableau vivant* of Frans Banning Cocq's famous militia company.

In museums, Rembrandt's popularity is enormous. In the Metropolitan Museum of Art in New York, the crowds seem particularly thick in the two rooms where most of the museum's Rembrandts hang—a well-established phenomenon, according to the staff. One of the Metropolitan's most notable paintings by Rembrandt is *Aristotle Contemplating the Bust of Homer*, which provides part of the impulse for a quirky book by Joseph Heller. *The Polish Rider* itself figures in a 1978 science fiction novel whose terminally ill artist hero has a print of the picture on a wall in his home; the Rider seems to him a gentle image of Death.[1] At the National Gallery in London, during the winter of 1988–1989, a special exhibition—featuring twenty paintings by Rembrandt, or hitherto attributed to him—attracted thousands to look not only at the pictures but at the details of microscopic paint analyses and X rays together with reports by the gallery's staff on their current attempts to determine which paintings are authentic Rembrandts. Christopher Brown, the deputy keeper, says the exhibition was not so much a direct reaction to the Rembrandt Research Project as it was an expression of the gallery's commitment to explain what its scientific experts do; but he adds, "In a way, all Rembrandt studies nowadays are a reaction to the Rembrandt Research Project. No Old Master has ever been given such concentrated attention." A more recent exhibition at the London National Gallery in 1992 (seen earlier in Berlin and Amsterdam), "Rembrandt: The Master and His Workshop," presented viewers with an authorized RRP situation report: fifty unquestioned Rembrandt paintings hung alongside forty that the team has now attributed to pupils. (A point of interest here is that the four rooms of Rembrandts were invariably jammed with visitors, while the three rooms devoted to the so-called workshop had plenty of room for viewers to appreciate the paintings, several of which were probably by Rembrandt.) A direct response to the very fact of the RRP is to be found in scholarly symposia that have been held in the past few years—in Boston, Frankfurt, London, Rotterdam, and San Antonio—at which members of the RRP have addressed some of the issues arising from their work, and fairly friendly discussions have taken place with such other experts as

Arthur Wheelock, Christopher Brown, Walter Liedtke from the Metropolitan in New York, Peter Sutton from the Boston Museum of Fine Arts, Seymour Slive from Harvard, and Egbert Haverkamp-Begemann from the Institute of Fine Arts of New York University.

Some of the debate on these occasions has spilled over into the press, and Rembrandt's name has appeared in headlines of inside-page articles in *The New York Times* and, in London, in features in *The Independent*, *The Guardian*, and *The Economist*. A Rembrandt on the cover of a Brazilian newsmagazine not long ago announced a story about Brazil's one known painting that may—or may not—be an authentic Rembrandt. Two recent books about Rembrandt have been widely reviewed. One, a modish presentation titled *Rembrandt's Enterprise*, by Berkeley professor Svetlana Alpers, considered the artist as an impresario and entrepreneur of his own achievement and personality, and treated his works as "collectibles" and commodities in a marketplace. Alpers's book gave many experts a chance to sound off on Rembrandt and to say, with some enjoyment, how "destructive," "diffuse," or "fanciful" they found her work.[2] The other book was an unorthodox biographical study by Gary Schwartz, an American long resident in Holland. Titled *Rembrandt, His Life, His Paintings*, the book regarded Rembrandt mostly in the light of his patrons, social connections, and surviving documents that concern him. It provided a view that many readers found absorbing if somewhat blinkered, particularly when, in a passionate epilogue, Schwartz (who calls Rembrandt "the Moby-Dick of Dutch art"[3]) erected on the basis of his archival findings a manipulative, uncharitable figure—a man who not only was unfamiliar, but seemed at a long remove from the artist who might have painted, etched, or drawn a good number of Rembrandt works, including *The Jewish Bride* and *The Hundred Guilder Print*. Schwartz has also been a successful publisher, of his own work and others', and his Rembrandt book has sold 100,000 copies in the Netherlands, Germany, Britain, and the United States.

As far as I know, Rembrandt has not made the movies since Charles Laughton donned a broad beret, picked up a paintbrush and palette, and got hooted at by the burghers of Amsterdam for perpetrating *The Night Watch*—a painting there has never been any reason for believing was less

than a success, then as now, at least in terms of fascinating crowds of spectators. Rembrandt's works influenced Goya, Turner, Delacroix, and Courbet, and many other artists have found them a source of inspiration. *The Polish Rider*, not unexpectedly, is an example of this. Giacometti did a small sketch in which he set the young man and his horse on a monumental plinth. Walter Sickert was one who saw *The Polish Rider* in London on its way from Dzików to Fifth Avenue. He wrote enthusiastically about it in a London weekly, *The New Age*, and, perhaps from a sense there were faults in the painting that would worry connoisseurs, chose the occasion to make a stand against all who sat in judgment on art but were not artists themselves. "This, gentlemen of the press, curators, critics, experts and others, is the claim we painters make in regard to the Old Masters. They are ours, not yours. We have their blood in our veins."[4]

A contemporary artist who feels this strongly is Nigel Konstam, an English sculptor and art teacher, who has written about Rembrandt's drawings and studio practices in *The Burlington Magazine* and the *Kroniek van het Rembrandthuis*.[5] Konstam has for some time been running a fierce campaign against the Rembrandt Research Project, driven in part by the same feeling as Sickert's—"He is ours, not yours." Konstam believes that modern connoisseurship is making an oeuvre for Rembrandt on the basis of faulty standards and a view of the artist that only art historians could have, and he wants to set up a committee of artists to keep an eye on what he calls "the excesses and dishonesty" of the connoisseurs. Stating his case, Konstam sounded a discordant note at a London National Gallery symposium in January 1988. He followed this up with a lecture and slide presentation at the London Arts Club, where, to a packed audience, he argued that the connoisseurs—the RRP in particular—were misdating Rembrandt drawings and misreading many of the paintings. "The Rembrandt we know is being cut to pieces on very shaky aesthetic grounds. Artists must step in." Konstam then put to the vote a motion of no confidence in present methods of Rembrandt scholarship; the motion was carried seventy-six to zero with six recorded abstentions. He has since issued a newsletter, *The Save Rembrandt Campaigner*, whose basic position is that the experts on Rembrandt "seriously believe

that they would understand him better if there were less of him to understand."[6]

In the face of such comments, many art historians tend to forget their own disagreements. Christopher Brown, grimacing, pleads, "Don't mention Nigel to me!" Michael Kitson, director of the Mellon Centre for British Art in London, says, "Artists aren't necessarily the best judges of art." Josua Bruyn replied to an open letter of Konstam's to the RRP: "The ways you and I look at works of art are completely different and even incompatible." But he acknowledged to Konstam that "you care as much for Rembrandt as I."

Caring for Rembrandt is a condition that Rembrandt, through his work, seems to create. Gary Schwartz recalls that as an undergraduate at New York University he visited museums to look at Rembrandts and was moved to tears. Many people experience an aftereffect more powerful than that created by the work of most other artists; coming out into the street from a museum, one finds a world heightened by what one has seen. One looks at faces (and sometimes in Holland they seem to be very much like those in the paintings), and they are of individuals, of people who— Rembrandt has reminded us—have separate souls. The power of the work and the affection we feel in response to it are what, naturally, art historians feel, too, but they find it hard to fit such intangibles into their equations, some even treating them with suspicion. In volume one of the *Corpus*, Josua Bruyn writes vexedly of the "rather questionable necessity" to "verbalize" and "do the artist justice by poetic evocation," and he points out that "deeply felt songs of praise have been written ... about highly suspect paintings in which no one believes today."[7] The fact that the public wants to hug to its bosom an artist about whose work and personality the scholars have what they think is a cooler, more accurate vision causes—among some scholars—a good deal of anguish. If only they could keep the Master unsullied by this widespread, ignorant adoration! And yet, presumably, Rembrandt himself is at the root of this warm response. Anyone who looks for Rembrandt, and attempts to delimit the Rembrandt oeuvre, without taking this into account, is seeing only some of the man and his work.

Clearly, the idea of the artist and his artistic personality that scholars bring to their job is important. If one is seeking Rembrandt primarily in his painted work, as the RRP seems to be doing, the concept of the "essential Rembrandt" ought to be based on the twelve paintings (one being *The Night Watch*) that are all that can be proved indisputably his, by way of documents and unbroken provenance. Gary Schwartz, who points this out, would argue also, as do others, that documents about Rembrandt's life and artistic connections are relevant to knowledge of what Rembrandt was involved in—and that in this respect the members of the RRP appear to have set to work with minds not only filled more by doubt than by preconceptions but also surprisingly unencumbered by archival baggage. Certainly one can understand the need scholars may feel to separate Rembrandt from Rembrandt legend. A good deal of effort has gone into dropping astern the cinematic drama about his life—the myth that this genius sprang from his father's mill and small-town anonymity to big-city fame and fortune, quickly followed by misunderstanding, bankruptcy, poverty, and death. But even when scholars have brought in many of the facts—about Rembrandt's connections with influential patrons, the success of *The Night Watch*, his big-spender art-buying habits, the manner of his insolvency, and his continued high reputation to the end of his life—even then, it is clear that the myth has something going for it, as myths often do. And one particular element of the myth that cannot be discarded is that Rembrandt was a genius.

What sort of genius was he? Arthur Wheelock has pointed out that he has been a different person for John Smith, for Abraham Bredius, and for W. R. Valentiner, a German connoisseur and museum director who between the wars fell prey to the Teutonic enthusiasm sweeping his country and hailed Rembrandt as the great *German* artist. He also has been claimed as a Jew and/or a biblical scholar. There is no doubt that people are capable of imposing their own fancies on an artist—particularly on Rembrandt. Gary Schwartz proposes that much of our reaction to art is an expression of our own personalities and cultures, for which the art object serves mainly as a catalyst.[8] Of Rembrandt's half-length portraits, he writes that "like so many Dutch Mona Lisas, [they] provide the viewer with a flatteringly fuzzy mirror for his own most profound reflections on

the meaning of life."⁹ Ernst van de Wetering has reminded us that Karl Marx was pleased that Rembrandt had represented Mary, the mother of God, as a peasant woman.¹⁰ In the early nineteenth century, there was admiration for Rembrandt as a Romantic hero, as a spokesman for individual freedom. The "romance" in Rembrandt has persisted, for good or ill: Kenneth Clark admires *The Polish Rider* as "that masterpiece of romantic painting," while Clive Bell complains that "except in a few of his later works, his sense of form and design is utterly lost in a mess of rhetoric, romance, and chiaroscuro."¹¹ Later, as if to rescue him from the bohemian associations of the sort of genius who caroused with a woman on his lap, which naturally led some—among them Ruskin—to assume he had been a drunk, there were efforts to turn him into the Dutch artist-as-burgher, worthy of a statue (which is absolutely terrible) in the Rembrandtsplein in Amsterdam.¹²

For the members of the Rembrandt Research Project, Rembrandt is also a genius—in their view, some critics think, a genius who could do little wrong, so faultless a painter that less than perfect works should not be ascribed to him. This view bolsters Rembrandt's role as a teacher and master of a workshop, and emphasizes his pupils and followers, who were induced to create many Rembrandtesque works. Egbert Haverkamp-Begemann points out that this notion is suitable for a democratic age, bringing as it does pupils into the limelight along with the master. Another view perhaps suitable for the more grasping elements of our age is that of Svetlana Alpers, who seems to consider Rembrandt as a marketer of self-performances, a mixture of Jackson Pollock, the action painter, and Ivan Boesky, the Wall Street freebooter. Alpers also appears to regard Rembrandt's acquisitions of many works of art and curiosities as the sublimation of avarice. None of these notions seems exclusive or, as some might suggest, necessarily anachronistic; romance existed before the Romantic age,¹³ and the worth of labor was noted before Marx. There are indications that many aspects of genius are to be found in Rembrandt—who also now and then felt the tug of bourgeois aspiration.

Yet it makes sense to recall what people thought of Rembrandt in his time. Early on, according to Jacob Orlers, burgomaster of Leiden, where Rembrandt grew up, "it became apparent that he would excel as a

painter."[14] To the courtier Constantijn Huygens, who visited Rembrandt and his colleague Jan Lievens and admired the painting of both, it was evident that Rembrandt at age twenty-three was capable of work that could "withstand comparison with anything ever made in Italy, or for that matter with everything beautiful and admirable that has been preserved since the earliest antiquity."[15] That he was something special was a judgment Rembrandt himself encouraged from the start of his career, painting portraits of himself in various moods and costumes in what became an unmatched record of an artist's life. Arthur Wheelock has drawn attention to the contemporary accounts of Filippo Baldinucci and Joachim von Sandrart, which concluded, to put it starkly, that Rembrandt was Rembrandt and his students were simply and unconfusably students. In 1664, five years before Rembrandt's death, a German scholar of the time, Gabriel Bucelinus, made a list of what appear to be all the artists he could think of in Europe, well-known and less so, including Michelangelo, Leonardo, and Rubens. He lists roughly a hundred by name alone. Only one artist's name is followed by a comment: "*Rimprant nostre aetatis miraculum*"—Rembrandt, the miracle of our age.[16]

The miracle persists. People visit museums and galleries all over the world and, standing before a work they believe is by Rembrandt, are suffused by an uncommon kind of identification with the artist. As Wheelock says, "We feel we know this man." Josua Bruyn acknowledges Rembrandt's pull when, in answer to a question about the great interest being taken in the RRP, he comments, coolly, "Some artists have an almost mystical appeal." There is a hint that he wishes Rembrandt did not.

Questions of Identity

I T IS generally agreed that, even for so diverse an artist as Rembrandt, *The Polish Rider*—which Bruyn recognizes as "*un tableau de legende*"— would be an unusual picture. Painter of portraits, biblical studies, history pieces, and a few landscapes, Rembrandt did not make a thing of equestrian paintings. In the Netherlands in the seventeenth century, there seems to have been no tradition of equestrian statuary[1] like that in Italy or Germany (where one recalls among many examples the Bamberg Rider [ill. 4], a thirteenth-century sculpture of a knight on horseback placed outside Bamberg Cathedral).[2] Only one other full-scale picture of a man on a horse is attributed to Rembrandt: the large portrait of Frederick Rihel (in the National Gallery, London) (ill. 5), where the rider is dressed in civic guard finery and mounted on a prancing gray steed. Although it has both forelegs in the air, this horse is otherwise curiously inanimate; it might be a merry-go-round horse, a studio prop. If the painting is indeed

a Rembrandt, or mostly a Rembrandt, Rihel's horse might well be an in-stance of student help.

The horse from the Dzików castle is a different specimen. Although its position, pace, physique, and even mood interested the painter, Rihel cer-tainly wouldn't have been seen dead on it. If not quite "full brother of Ro-zinante," like Parson Yorick's nag in *Tristram Shandy*, it is well on the way to being so. Its eagerness of forward movement may arise from hope of getting a decent bag of oats at the next stop on the road. Other Rem-brandt horses are to be found as subsidiary elements in drawings and etchings, for instance the group of wild-looking horses in an etched depic-tion of a lion hunt, and a restrained horse (and rider) in the fourth state of *The Three Crosses* (ill. 6), which Rembrandt borrowed from a Pisanello equestrian medal.[3] In *The Polish Rider*, the horse is an elderly stallion, a serving horse, not a parade horse. It is quite unlike the plump horses one sees in cavalier paintings by Aelbert Cuyp or Thomas de Keyser; in his-tory paintings such as *The Triumph of Mordecai*, by Rembrandt's teacher, Pieter Lastman; or in the military pictures of Philips Wouver-man. Kenneth Clark detected in this difference a recognition by Rem-brandt that "full, round curves had become one of the deceptive clichés of classical art. And in nothing were they more indicative of power and pomp than in the smooth swelling rumps of horses. The horses in Rubens or in Velasquez' portrait of the Duke of Olivares assert by their great curves the power of their riders. No doubt seventeenth-century horses really did have much heavier hindquarters than show jumpers have to-day, but even so, there is an element of symbolism in these powerful arcs. This was precisely the assertiveness against which Rembrandt all his life was in rebellion."[4]

The horse that seems to haunt that of *The Polish Rider* was mentioned by A. M. Hind in his 1932 book on Rembrandt: "a drawing of a skeleton of a horse at Darmstadt which might even have been done with a view to *The Polish Rider*"[5] (ill. 7). Julius Held has concluded that this drawing of a skeletal horse and skeletal rider—unanimously accepted as a Rem-brandt—was done in the anatomical theater of Leiden University, which Rembrandt may have visited in connection with work on his *Anatomy*

Lesson of Dr. Deyman. As Held notes, the Darmstadt drawing and the Frick painting have many striking similarities:

> In both, the group is seen from a low eye level. In the drawing, this is evident from the position of the feet of the rider and the relationship of his shoulder to his neck; it is equally obvious in the Frick canvas if we look at the relative position of the shoulders or notice the sole of the shoe. There are still closer similarities if we examine the horses. They have the same pace, although that of the skeleton horse is less rapid, closer to a walk. The hind legs are placed almost identically, even to the slight anomaly ... that the standing hoof is seen in profile while the lifted one is slightly foreshortened. The cropped tail [in] the Frick picture, an uncommon feature at that time, exactly corresponds in length to the tail-bones seen in the drawing.... All this results in the feeling that the horse of the painting has literally been brought back from the dead but still betrays his macabre origin in his bony appearance and pale color. The broad, isolated brush strokes, especially about the legs, reveal the anatomical structure almost as clearly as do the corresponding pen lines in the drawing.[6]

One might mention at this point a simple and I think hitherto unremarked aspect, which is how potent the image is—a youth on horseback. No similar punch would be felt today from, say, a picture of a young man in a car, although the movies have made an attempt with actors on motorcycles. Does the potency arise from the almost symbiotic relationship of two living creatures, horse and rider? Perhaps the fact that we have no equally powerful image now may be another reason for the impact of the equestrian picture: it is something altogether lost.

As for the identity of the rider and the "subject" of the picture, there are at least twenty different theories. After being simply a *cosaque à cheval* in the Polish royal collection, the rider by the mid–nineteenth century seems to have been adopted by the country in which the painting resided. Held discovered among Polish scholarly accounts of the picture a reference to its having been seen at Dzików in 1842 by Kajetan Koźmian, a Polish poet and patriot. Koźmian suggested that the rider might have been an officer in a mercenary regiment led in the early seventeenth century by a Polish condottiere named Alexander Lisowski. Koźmian appears to have encouraged a tradition that other scholars, including W. R. Valentiner and

Otto Benesch, accepted without question. Similarly, the German Wilhelm von Bode called the rider "a Polish magnate." One problem with the Polish connection, noted by Held, is the young rider's lack of a mustache; a mustache is said to have been de rigueur for seventeenth-century Polish men (and, indeed, remains so for many today).

The rider's clothing is thought by the Polish costume historian Z. Zygulski to be wholly Polish, but Held considers it similar to that worn by assorted eastern European light horsemen, "Hungarians and Poles alike."[7] (Held also observes: "One cannot help suspecting that the painting, had it been found by accident in a Hungarian castle instead of a Polish one, might have become famous, with equal if not better right, as *The Hungarian Rider*."[8]) Yet any discussion of the rider's costume should be qualified by the recognition that Rembrandt was not always known for historical exactitude when it came to dressing his characters. Colin Campbell, a British art historian, writes: "His biblical characters are often to be found dressed arbitrarily in costume of widely varying origins: Turkish, Persian, or Indian, for example."[9] The clothes he wears in the 1658 self-portrait make him look like a Venetian nobleman—or, some think, like a Dutch burgher affecting to be Zeus. Although Zygulski and other students of the subject believe that the apparent homogeneity of clothing in *The Polish Rider* puts the painting in the realm of portraiture, for Rembrandt the Polish costume might have had nothing to do with a Polish subject. In any event, Leonard Slatkes, professor of art history at Queens College in New York, sees more reliance here on Persian and Mongolian sources; for him, the rider's coat is a padded caftan, which "Rembrandt understood ... [as] a form of light armor."[10] Rembrandt copied Persian and Moghul miniatures, which obviously fascinated him. He also had a considerable collection of exotic costumes and varied weaponry. Many seventeenth-century Europeans were keenly aware of threats of incursions from the East, and Rembrandt's interest in military hardware—noted by Baldinucci and other contemporary observers— was displayed in his fondness for actually owning all sorts of ancient and modern arms, some of them Eastern, and using them in various pictures. Held has remarked on the similarity of the curved saber in *The Polish*

Rider to that in the 1641 etching *The Baptism of the Eunuch*, and it looks to me like the same weapon hanging on a wall in his 1630s painting *The Raising of Lazarus*.[11] This interest may have rubbed off on some of his students, or did Ferdinand Bol simply borrow some of the Master's accoutrements for his *Portrait of a Boy in a Polish Costume* (in the Museum Boymans–van Beuningen, Rotterdam)? In this painting, a sweet-looking little lad in a golden-yellow coat holds a war hammer in one hand while a shield, drum, cuirass, and sheaf of arrows sit on the bare-boarded floor beside him.

Even if lacking a mustache, the *Rider* has had its Polish connections pursued further by the Polish art historian Jan Białostocki, who has traced cultural links between Poland and Holland in the seventeenth century, and contacts of Rembrandt and his family with various Poles.[12] When Rembrandt first came to Amsterdam, he lived and worked with the art dealer Hendrik Uylenburgh, who was probably born in Poland, and whose father or grandfather was the Polish royal cabinetmaker. (One of many portraits done by Rembrandt in those first, busy Amsterdam years is *A Polish Nobleman*, now in the National Gallery, Washington.) Rembrandt met and married Uylenburgh's Frisian cousin Saskia. Her sister Antje married Jan Makowski, a Polish Calvinist professor of theology at Franeker University who was known for holding wild late-night parties with his students.[13] Uylenburgh himself was a Mennonite, and members of this Anabaptist sect had traveled from the west to settle in Poland in the sixteenth century. (I doubt whether Henry Clay Frick was aware of Rembrandt's Mennonite contacts; his own mother had Mennonite forebears in the Rhineland-Palatinate.[14]) In the seventeenth century, a number of Mennonites moved from Poland to Holland, presumably attracted by Dutch tolerance and living standards. So did a related group of anti-Trinitarian dissidents, the Socinians, or Polish Brethren. Białostocki suggests that *The Polish Rider* is the image of a fighter for religious freedom, perhaps related to Jonasz Szlichtyng, a Socinian Pole who took refuge in Holland, and whose treatise on religious toleration and the separation of religious and state affairs was published in Amsterdam in 1654. His nom de plume happened to be "Eques Polonus." *Eques* connotes a knight as

well as a horseman. A Dutch theologian who disputed with Szlichtyng called him the "Poolsch Ridder"—a term which has the same chivalric implications.[15]

Another art historian, Ben Broos, a Dutchman, more recently has proposed that *The Polish Rider* is a portrait of a member of the Ogiński family.[16] As mentioned before, two Ogińskis were in the Netherlands in the mid–seventeenth century, studying at Leiden and Franeker. The name *Ogiński*, says Broos, can be translated as "of the fire"—and he suggests that the campfire in the right background of the picture is an emblematic reference to the sitter's name. Moreover, the rider's full quiver is seen as a token of nobility. Of the two Ogińskis, Broos plumps for Simon, who married a Dutchwoman and had three children by her. But as Julius Held has pointed out lately, Simon Ogiński was thirty-four in 1655, hardly a youth.[17]

Before leaving the Polish connection, one might ponder other implications of the painting's present title for the modern viewer. The resonance of the words "Poland" and "Polish" is great. This was so before Solidarity, before 1939 (when Polish cavalry attacked German Panzer divisions with obsolete weapons), before Chopin. We recall "gallant little Poland" and its position between Germany and Russia—as the Poles say, "like Christ, crucified between two thieves." In a footnote to his essay on *The Polish Rider*, Julius Held quoted the poem by F. Warre Cornish, which accepted that the young man was a Pole on a romantic and bold errand, and closed with the lines:

Ah, chivalrous Poland, forgotten, dishonored, a slave
To thyself and the stranger, fair, hapless, beloved of the brave.[18]

Much scholarly effort has gone also into finding pictorial and literary connections for *The Polish Rider*. Artists whose prints of mounted warriors may well have influenced the painting include Stefano della Bella, an Italian who visited Amsterdam in 1647 and admired Rembrandt's work; Albrecht Dürer, whose engraving *Knight, Death, and the Devil* was widely known; and Lucas Cranach, whose 1506 woodcut *A Saxon Prince on Horseback* shows a young man on a horse, also moving from

left to right, with a steep hillside behind (ill. 8–12). Kenneth Clark has observed in the steed of *The Polish Rider* a reflection of Death's horse in Dürer's print *The Four Horsemen of the Apocalypse*.[19]

The Bible has been proposed by a number of people as a source for the subject of the painting. Michael Rubinstein believes the rider is Absalom, from the Old Testament story of David.[20] Colin Campbell proposes that the youth is the Prodigal Son, setting out on his journey to a far country[21]—although it has been pointed out that generally the Prodigal Son is depicted carrying a purse with his share of his father's estate, often has a dog for company, and would hardly be riding fully armed on a semi-starved horse, as does Rembrandt's rider. Leonard Slatkes thinks the rider may be the young David, prefiguring the heroic Christian knight who is the subject of a 1610 poem by the Dutch writer Joost van den Vondel; the citadel of Jerusalem, as described by Flavius Josephus in his *History of the Jewish War*, is seen in the background.[22] One New York resident has donated to the Frick a synopsis of his belief that the picture represents Christ on his Second Coming.[23]

Vondel has cropped up before, in W. R. Valentiner's theory that the rider represents Gysbrecht van Amstel, a mythical Dutch hero of the Middle Ages, and the subject of a Vondel play that was frequently performed in Amsterdam and was thus, one might assume, familiar to Rembrandt.[24] A bonus here is that van Amstel eventually fled to Poland; a drawback is that he was an old man when he did so. Yet another play has been suggested by Gary Schwartz, the melodrama *Tamerlane*, by Joannes Serwouters.[25] It was performed in Amsterdam in September 1657, starring an actor named Gillis Nooseman, whose props, according to Schwartz, included Polish costumes, and featuring a live horse that was ridden on-stage. The painting may therefore be of Tamerlane in pursuit of Bayazet, the Turkish sultan whom the Mongol chief overthrew in 1402. The painting would thus be of a Mongolian rider, even if in Polish costume; Schwartz thinks this would have made the painting easier to sell to Michal Kazimierz Ogiński in the late eighteenth century. Peter Sutton has argued against this theory in a review of Schwartz's book.[26] "Serwouters' melodrama," Sutton writes, "never describes such a scene, and, typically,

offers no direction for its staging; Schwartz freely infers it from the dialogue and the fact that a live horse is known to have been used in the play, but only certainly in a later equestrian scene."

Another drama that has been proposed is *Sigismund, Prince of Poland*, which was also produced in Amsterdam in the mid–seventeenth century.[27] In this play, one of the characters is a woman who dons armor and disguises herself as a man in order to go to war. (The first actress to appear on the Amsterdam stage, Adriana Nooseman, did so in 1655.[28]) In fact, several observers have noticed something of a feminine quality in the young person on horseback.[29] Kenneth Clark says the rider "has an almost feminine beauty." He suggested that the artist had used the same model who posed for the figure of Potiphar's wife in two versions he did of the biblical story of Joseph.[30] But although Rembrandt painted two other pictures in the mid-1650s in which the gender of a figure is disputed (one in Glasgow, the second in Lisbon, and both representing either Alexander or Pallas Athena), I would say that the man in *The Polish Rider* looks much more like the Joseph than the woman in the 1655 *Joseph Accused by Potiphar's Wife*, now in the National Gallery in Washington (ill. 13).

A more frequent and specific proposal has been that Rembrandt's model for *The Polish Rider* was his son Titus. Several Polish scholars have seen Titus in the rider,[31] and so did Walter Sickert, although he thought the head was based on "drawings, and from a memory of expression and character"—which suggests that he believed Titus was dead when the painting was made.[32] But Titus did not die until 1668, a year before his father. Titus was fourteen in 1655, and if the painting was done in that year, as most seem to agree it was, then Titus would have been too young to be the rider. No date is visible on the present canvas, but 1655 or so has never been disputed while the painting has been attributed to Rembrandt. Yet the young man looks a good deal like an older version of the boy we think of as Titus, who appears in numerous paintings and drawings by Rembrandt, portrayed with parental affection. One picture that comes to mind, painted about this time, is of Titus sitting at his desk, apparently contemplating what to write next (ill. 14). This is a work in which the modeling and painting of hair, flesh, eyebrows, eyes, lips, and the right side of the face with light falling on it bear the strongest resemblance to

The Polish Rider, even if in the *Rider* certain features such as cheeks and chin are differently, perhaps just more maturely, shaped.

This painting, *Titus at His Desk*, led Roger Fry to describe the impact of a Rembrandt painting, or what might be called the Rembrandt effect. (Fry did not, as far as I know, publish anything about *The Polish Rider* after bringing it from Poland.) Fry writes about the front of Titus's desk:

> This is a plain flat board of wood, but one that has been scratched, battered and rubbed by schoolboys' rough usage. Realism, in a sense, could go no further than this, but it is handled with such a vivid sense of its density and resistance, it is situated so absolutely in the picture space and plays so emphatically its part in the whole plastic scheme, it reveals so intimately the mysterious play of light upon matter that it becomes the vehicle of a strangely exalted spiritual state, the medium through which we share Rembrandt's deep contemplative mood. It is miraculous that matter can take so exactly the impress of spirit as this pigment does.[33]

One other feature of *The Polish Rider* may be worth noting: the sense of mission given forth. Like young Lochinvar in Walter Scott's ballad, this rider is on a quest. If not a huntsman, he is in some sense a hunter. Colin Campbell refers to the "purposefulness" of rider and horse; the youth has an air of riding forth in search of his destiny.[34] Kenneth Clark writes that "his gaze, like that of his horse, is focused on some unattainable objective."[35] For Julius Held in 1944, the young rider could at one level be taken for a *grenswacht*, or border guard, but beyond that he was "obviously an idealized figure, a glorified representative of a whole military group," that is, Christian warriors fighting such infidels as Turks and Tatars. "The spirit of the Crusades indeed still sheds a last gleam of light on the youth in Rembrandt's painting."[36]

A last word on the "subject" of *The Polish Rider*: The Amsterdam poet and playwright Gerbrand Bredero, who started his working life as a painter's apprentice, has a character in his 1613 comedy *The Miller's Farce* say, "Painters just paint any old thing that pops into their head."[37]

Connoisseurship

WHAT POPPED into the painter's head and what thereafter materialized out of the painter's efforts to express this idea, yearning, or burden in paint, on canvas or panel, framed and hung on a gallery wall, may at some point interest art historians. With the passage of time, connections in the form of documents and provenance often become frail, or fail altogether. An art historian then may find useful employment in saying, "So-and-so did this work," or, "So-and-so did not." These functions of attribution and deattribution can have financial effects, the former adding or confirming value, the latter diminishing it, depending on the standing of "So-and-so." Experts have done well from their expertise. But one can see immediately that for the Rembrandt Research Project, which has gone in almost entirely for deattributions of a great master's work, there is no percentage in it. No doubts can arise of the kind that eventually blemished the reputation of Bernard Berenson, who often received twenty-five per-

cent of the price of pictures sold by Joseph Duveen for which he, Berenson, had provided attributions.

Not all art historians are concerned with questions of attribution. J. A. Emmens, for example, one of the founding members of the RRP, was more interested in iconography, the study of the subject, details, and associations of a picture. Indeed, there are fierce debates about the subjects of other Rembrandt pictures, particularly those with biblical and classical figures, and consequently many arouse arguments that do not always seem to aid comprehension. But for art historians, isolating the author of a picture is part of the essence of connoisseurship—the skill of looking closely at a work of art, and determining the date, place, and process of its creation. In the past, this has been very much a single-handed craft, and has depended on one primary tool, the trained eye.

One of the first people to attempt to establish the rules of the craft was Jonathan Richardson (1665–1745), a prominent English portrait painter. Richardson's writings on the subject, which included his "Theory of Painting," "Essay on the Art of Criticism," and "The Science of a Connoisseur," were reprinted in a collection edited by his son and published in 1773.[1] This then little-known science—"Connoissance," Richardson called it—was to be "a new scene of pleasure, a new innocent amusement, and an accomplishment." It would, he thought, occupy the time of the leisured classes, keep them out of mischief, and show a good example of "improvement" to the "common people."[2] The first thing one had to do to become a good connoisseur was avoid prejudices and false reasoning; one should accept nothing on trust. "Great care must be taken as to the genuineness of the works on which we form our ideas of the masters; for abundance of things are attributed to them, chiefly to those that are the most famous, which they never saw." In judging who painted a picture, one should furnish oneself with "as just and compleat ideas of the masters as we can," both from history and from their works. To be good connoisseurs, we should look at all parts of the masters' lives and "the various kinds and degrees of goodness of their works, and not confine ourselves to one manner only, and a certain excellency found only in some things they have done, upon which some have formed their ideas of those

extraordinary men, but very narrow and imperfect ones." For, Richardson advised, "a great variety is to be found in the works of the same men from causes as natural as youth, maturity, and old age." Artists are affected by "indisposition or weakness, the weather, the season of the year, joy, and gaiety, or grief, heaviness, or vexation. . . . Some [works] are done in hopes of considerable recompense, others without any such prospect." Yet there is "in all the masters, though not in all equally, a certain character and peculiarity that runs through all their works in some measure, and which a good connoisseur knows, though he cannot describe it to another." Moreover, the voices and handwriting of human beings are all different. "If, in forming an A or a B, no two men are exactly alike, neither will they agree in the manner of drawing a finger or a toe, less in a whole hand or foot, less still in a face."[3]

Richardson noted that connoisseurs disagreed: this arose not "from the obscurity of science" but "from some defect in the men." Some were mere "picture-jockeys who will make what advantage they can of the credulity of others." Richardson himself turned often to Raphael for illustration, but he was fairly unusual in his time in finding many examples in Rembrandt, too. He admired Rembrandt for his composition and for his ability to put as much variety in a picture as the subject would admit. After a laudatory description of one work, "Our Lord healing the sick," Richardson allowed some of the contemporary feelings about Rembrandt, the miller's son, to show: "I made choice of this, not only as being at least equally remarkable with the best I could have found, but to do justice to one, who though he hath excelled most others in some parts of painting not the least considerable, yet having wanted (generally, not always) grace and greatness, and adhering to common nature, common to him, who conversed not with the best, his surprising beauties are overlooked in great measure, and lost with most, even lovers of painting, and connoisseurs." Richardson junior adds a footnote: "This was written before Rembrandt came into the immense reputation which he then justly possessed; and which is, surely, in some measure, owing to my father's frequent mention of him . . . with admiration and fondness."[4] At the time of his death, Richardson senior owned more than a hundred drawings by Rembrandt.[5]

Richardson has a surprising modernity; he serves to underline our suspicion that in art history, as in many other skills and professions, "progress" tends to be cyclical rather than linear. And it must be admitted that already in his essays an impression is given of connoisseurship as an elegant private society, whose members not only need "a delicacy of eye" but "must be conversant with the better sort of people."[6] (To my ears, a term that sounds a little less affected and more to the point than "connoisseur" is the Dutch *kunstkenner*.) One of the best minds in the late eighteenth century thought there was a bubble here to be pricked. Dr. Johnson's friend Mrs. Thrale recalled an occasion on which the good doctor had asked a group of artists and art lovers if anyone knew what the motto "*Et in Arcadia Ego*" meant at the bottom of a portrait of two ladies by Sir Joshua Reynolds. "None of them knew that the Thought was borrowed from N. Poussin who places three Shepherds & a Nymph or two in a showy landscape with a Tomb in the background and a Death's Head on it with this motto—*Et in Arcadia Ego—Mors Loquitur* of course: Mr. Johnson who despised Connoisseurship exceedingly, might reasonably have been suspected of ignorance on such a Subject—but Reynolds himself to borrow the Motto, when he understood not the meaning—Oh Fye!"[7]

Since the eighteenth century, there have been various developments in the craft practiced by connoisseurs. It has become professional—connoisseurs are generally trained in universities and museums, and they are paid for their expertise; and they have taken advantage of many technical and scientific methods of examination. Even so, the craft is one in which the gifted amateur has often made a contribution. As Gary Schwartz has pointed out, many nonacademics, such as people who work for auction houses, often have the right sensitivity to style to enable them to identify the authors of artworks.[8] A particularly influential amateur was Giovanni Morelli (1816–1891), an Italian physician who became an expert on Renaissance art. An Italian nationalist in the 1860s, Morelli wrote essays, at first in German and camouflaged by a Russian pseudonym, in which he criticized the way Italian galleries presented paintings with misattributions or claimed they were originals when they were in fact copies. Morelli frequently crossed swords with Wilhelm von Bode, director of

the Kaiser Friedrich Museum in Berlin, who had pronounced as authentic Raphaels some of the pictures Morelli said were copies done by highly skilled Flemish artists. Bode, originally a lawyer, was annoyed by Morelli's approach to paintings, which he thought sprang from the latter's training as a surgeon, and which concentrated on the different ways in which artists delineated various parts of the human body: ears, eyes, nose, hands, and so on. The study of these forms, Morelli wrote, can "aid us in distinguishing the works of a master from those of his imitators, and control the judgment which subjective impressions might lead us to pronounce."[9]

It was Morelli's conviction that the artist gave himself away—that is, identified himself—unwittingly. "As most men, both speakers and writers, make use of habitual modes of expression, favourite words and sayings, which they often employ involuntarily and sometimes even most inappropriately, so almost every painter has his own peculiarities, which escape him without his being aware of it."[10] Morelli had and still has a great impact. In his day, his value seems to have been in furnishing a practical tool to determine the authorship of paintings that could be set against tests involving documentary evidence, "intuition," and such woolly nineteenth-century notions as "spiritual content."[11] Yet some supporters claimed more for Morelli than he claimed for himself: as he said, his method was to be no more than an "aid." And he wrote a friend, Jean Paul Richter, that his method was never intended to inject or infuse "the gift of divination" into those who had not been granted it by nature.[12]

His method, in any case, had flaws. As Richard Wollheim has noted—and Jonathan Richardson had already observed—artists are not always bound by their own habits. One artist forced outside his own repertoire, mentioned by Wollheim, is Filippino Lippi, who, when set the task of placing a series of men's heads in profile close together in a work, varied his usual highly uniform way of doing ears.[13] E. H. Gombrich has asked why Morelli's supposedly scientific method "produced results only when used by the most gifted of experts and led to absurdities in unskilled hands. Why was it that *the true connoisseur* [my italics], such as Max J. Friedländer, turned away from any pretence at rational analysis and pro-

claimed that the recognition of personal style was merely a matter of intuition based on experience?" Gombrich then attempts to answer those questions:

> Perhaps the analysis of language perception indicates a direction in which an answer to this puzzle may lie. The personal accent of the artist is not made up of individual tricks of hand which can be isolated and described. It is again a question of relationships, of the interaction of countless personal reactions, a matter of distribution and sequences which we perceive as a whole without being able to name the elements in combination. Friedländer may well have been right in declaring that the trained eye is the most sensitive recording apparatus for such total impressions that defy analysis.[14]

Among those impressed by Morelli was Sigmund Freud, who was interested in the Morellian notion that an artist's individuality, as identifiable as handwriting, was revealed in areas where—working in a routine fashion—he forgot himself. In his 1914 essay "The *Moses* of Michelangelo," Freud said that the pleasure he got from a work of art depended on his being able to explain what the source of its effect was; if he could not do this, he was "almost incapable of obtaining any pleasure." That is, there was no pleasure without rationalization. And he acknowledged having read Morelli before he had heard about psychoanalysis. Freud wrote: "It seems to me that his method of inquiry is closely related to the technique of psychoanalysis. It, too, is accustomed to divine secret and concealed things from unconsidered or unnoticed details, from the rubbish heap, as it were, of our observations."[15]

Although Bernard Berenson thought Morelli's method was too wholeheartedly empirical and lacking in "philosophy," he went along with the interest in morphological details, "the execution of which is invariably different in every painter ... bearing in mind, to start with, that the less necessary the detail in question is for purposes of obvious expression, the less consciously will it be executed" and "the more by rote, the more likely to become stereotyped, and therefore characteristic." Berenson concluded that these details were peculiarly characteristic in proportion as they were not vehicles of expression, did not attract attention,

were not controlled by fashion, and escaped imitation and copying by being "minute in their peculiarity."[16]

Despite Morelli and various modern techniques, some experts continue to support what might be called a prescientific approach to—in Richardson's words—"the knowledge of hands."[17] David Ebitz, a participant at a recent scholarly symposium on connoisseurship, praised the craft as a form of irrational knowing by recognition rather than analysis.[18] This seemed to hark back to Berenson himself. One of the first experts to make a full-time career of connoisseurship, BB said with quite endearing candor that when he saw a picture, in most cases he recognized it at once as being or not being by the master it was ascribed to. "The rest is merely a question of how to try to fish out the evidence that will make the conviction as plain to others as it is to me."[19]

Scientific Analysis

JUST WHERE the Rembrandt Research Project fits into the history of connoisseurship is a question that requires patient probing. Some observers see the team as still practicing Morellian methods, concentrating, for example, on such a common, seemingly unimportant aspect of a composition as the way in which lace collars and cuffs are painted. (Clues afforded by studies of this are discussed at length in volume two of the *Corpus*.) Some find it surprising—and others, illuminating—that the RRP should admit to such reliance on what is, after all, the time-honored tool of connoisseurship and employ such traditional terminology of the profession as "loosely painted" and "refined handling," when the team's original platform was to use "up-to-date methods of investigation" in the service of a "radical revision of the Rembrandt canon."[1]

Some up-to-date methods have certainly been employed. The Project has made close examination of canvases, to determine the density of threads and the presence of cusping, a scalloping deformation that a

stretched canvas may show along its edges, if it is original and of the original size. As mentioned before, the team has also used such scientific aids as dendrochronology, to establish the age of the wood used in picture panels; chemical and microscopic analyses of minute paint samples, which show the various layers of paint and the basic ground; and infrared, ultraviolet, and X-ray photography, to show certain layers of underpainting. X rays, however, which have been used since the 1920s to examine paintings, detect the distribution only of lead white and other lead-based pigments, and thus provide only a somewhat simple view of just one aspect of groundwork. For much of this technical assistance the RRP has depended on work already done by major museums, for instance the National Gallery in London, which has been looking closely at its own Rembrandts to discover how the artist prepared his canvases and panels and laid on the paint. In its 1988 "Art in the Making" exhibition, viewers could see enlargements of tiny paint fragments which looked like colorful bacteria under a microscope; some fragments gave an idea, for example, of how little vermilion—which was expensive—was needed to give the effect of red.

Probably the most sophisticated scientific analysis of the structure of a painting is furnished by autoradiography. In this process, a painting is bombarded with radioactivity and then covered with film; the film is removed in stages over a number of days, and thus provides readings on different layers of the paint. This procedure has been undertaken so far by only a few museums, among them the Gemäldegalerie in Berlin and the Metropolitan in New York, which have access to nuclear research facilities. (The Metropolitan's work is done at Brookhaven National Laboratory on Long Island.) Maryan Ainsworth, a research fellow and former scientific investigator at the Metropolitan, believes that because the procedure can "distinguish fine details of paint application, it is useful in questions of attribution and authenticity. In some cases, a painting of a later century may be recovered under a purportedly earlier one, or a 'period' work may be found totally lacking in conventional structure." One painting given the treatment was the Metropolitan's *Christ with a Pilgrim's Staff*, which bears the signature "Rembrandt" and the date "1661." Autoradiographs show that the background was "reworked in

an unusually large number of layers to approximate those effects that Rembrandt could achieve with an economy of means." Because of this and other factors revealed by autoradiography, Ainsworth and her colleagues feel it is the work of a pupil.[2]

Autoradiography is thus helpful in giving evidence of an artist's working methods and enabling a more comprehensive study of the character of brushstrokes—part of the artist's "handwriting"—which may have darkened and become less legible over time. Some paintings attributed to Rembrandt that have been put through this treatment have revealed preliminary, below-the-surface sketches that are remarkably similar to the artist's pen-and-wash drawings. Yet Ainsworth doesn't claim the earth for the method. In their book on the subject, she and several other authors write: "Autoradiographs are sometimes misleading in that they simplify what actually may be a more complex handling of paint."[3] Julius Held thinks that autoradiography doesn't "allow the reconstruction of the sequential process of the artist's work with any degree of accuracy." He continues: "Nuclear science has its place in many areas of this technological age; but in the area of connoisseurship, the experienced eye of the scholar armed with a good magnifying glass will still have its place." And he points out that scientific tests need interpreting, and that inevitably subjective elements creep into the process of interpretation. In regard to some of Horst Gerson's attributions, Held writes: "His occasional references to X-ray evidence, flawed as they are by an incomplete understanding of how to read the X-ray image, were concessions to the growing trust in technology as a substitute for decisions inevitably based on subjective elements."[4]

A not uncommon objection to scientific research is that it may have a suffocating rather than an invigorating effect on the connoisseur. A writer in the *Times Literary Supplement* not long ago expressed the fear that laboratory investigations might "muffle" our real understanding of works of art. However, the same writer went on to cite a case from a previous century where scientific knowledge might well have helped: that of the collector W. Hope, who owned a Rembrandt painted on a mahogany panel, which he had bought for a goodly price. It seems that when Mr. Hope was told that mahogany was not used as a painting surface in Rem-

brandt's day, he burned the painting. We now know that mahogany was so used at the time.[5]

The Rembrandt Research Project, in any event, seems to be backing off from its early commitment to scientific analysis. It has ignored the findings about two works of the 1630s painted—in seemingly similar technique and materials—on panels that investigators have determined are of wood from the same tree; one panel has been accepted as a Rembrandt, the other rejected. The Project is in dispute with the Metropolitan Museum in New York about the authenticity of two portraits that, partly on the basis of autoradiographs, the Metropolitan is sure are by Rembrandt, and, partly on the basis of such Morellian details as lace, the Project is sure are not (I will look at this controversy later in more detail). In volume two of the *Corpus*, at the end of his chapter on analyses of canvas, Ernst van de Wetering observes: "This sort of research takes an enormous amount of time and energy, and does not always pay off."[6] And in their catalogue of the "Art in the Making" exhibition, Christopher Brown and his associates at the National Gallery in London write: "Technical investigation can assist in matters of attribution, but only to a limited extent"; it "should not be regarded as a panacea. Scientific examination will, broadly, establish the outer limits within which the art historian must work. It can identify later copies and recent fakes, and it can establish conventional patterns of procedure. However, the very nature of the apprenticeship system in the Netherlands in the seventeenth century meant that the pupil would adopt his master's method of working, and so it is rare that technical analysis can help us distinguish between the two."[7]

Rembrandt's School

Pupils and master: We arrive at the prickly, all-important subject of Rembrandt's school, or workshop—his students, assistants, and followers. Estimates of the size of Rembrandt's oeuvre are obviously affected by the numbers of Rembrandtesque works that can be convincingly attributed to the more than fifty artists who studied and worked with him; and such estimates are all the more meaningful if the artists to whom works are reattributed can be named. Egbert Haverkamp-Begemann comments, "In the nineteenth century, the whole idea of genius precluded the assumption that any of these Rembrandtesque works was by anyone other than Rembrandt." The early-nineteenth-century Anglo-Swiss artist Henry Fuseli, emphasizing Rembrandt's unique genius, said on one occasion, "Rembrandt had no pupils."[1] But we think differently now. Bob Haak observes: "The idea of Rembrandt's school is something that has developed over the past twenty years. Many pictures I thought were eighteenth- or nineteenth-century imitations turn out to be by his pupils."

Haak's first statement is a little hard on John Van Dyke, who in 1923, believing that "the works of the pupils are given to the master, which do not enrich him but make the pupils poor indeed," carved the essential Rembrandt oeuvre down to forty-eight paintings.[2] The Rembrandt who emerged from such a reduction struck the English art writer R. H. Wilenski as one of "singular dignity and simplicity . . . whose work is purged of all bombast, romantic vagueness . . . and melodrama."[3] However, as Wilenski went on to note, he was also an artist whom it would be hard to conceive of as painting *The Night Watch*, which Van Dyke continued to credit him with. But Van Dyke was flying against the generally inflationary tendency of his time, and Haak is right to the extent that the Rembrandt school has received a good deal of renewed and profound scholarly attention in recent years, and has proved important in the winnowing process.

Who are these artists who are being dragged out from under the Master's enormous shadow? There could be many of them, for, as Seymour Slive has pointed out, "by the end of Rembrandt's life, it [would] be difficult to think of an Amsterdam artist who did not learn or borrow something from him."[4] The RRP notes that "no contemporaneous roll call of the 'population' of Rembrandt's workshop has survived."[5] The longest list of those associated with him was that given by Arnold Houbraken, whose *De groote Schouburgh* of 1718–1721 is an indispensable source for the lives of seventeenth-century Dutch artists.[6] Houbraken was, one would think, working from evidence furnished by many who had known Rembrandt or some of his pupils, but that was half a century after the Master's death. A contemporary witness was Joachim von Sandrart, a German painter and writer on art who was in Amsterdam in the early 1640s. In his *Teutsche Academie* (1675–1679), von Sandrart wrote that Rembrandt's house was "crowded with almost innumerable young men who came for instruction and teaching." They were from the Netherlands and elsewhere in Europe, and generally paid a hundred guilders a year for the privilege. Some had already worked with other masters and were certainly advanced pupils, even mature students. From 1637 to 1645, Rembrandt's need for workshop space was such that he rented a warehouse on the Bloemgracht, a canal in the Jordaan district of the city. There, accord-

ing to Houbraken, "each of his pupils had a space for himself, separated by paper or canvas, so that they could paint from life without bothering each other." According to von Sandrart, Rembrandt made up to 2,500 florins annually from selling his students' work.[7] In the late 1640s and the 1650s, Rembrandt had fewer pupils, and they were apparently accommodated in his large house on the Breestraat. When it was eventually sold, a clause in the deed stated: "The owner will take with him two stoves . . . and various partitions, set up in the attic for his pupils." A drawing, now in Darmstadt, by one of his students shows Rembrandt conducting a life class: the model on a low plinth, pupils leaning against the wall or squatting as they draw, and the Master, in his working beret, casting an eye over their work[8] (ill. 15).

Rembrandt, like other painters with pupils, traded in their work; at that time, being an apprentice involved making copies of one's master's paintings, and the copies were sometimes signed by the master. But there seems to be no proof that Rembrandt did this, although as Wolfgang Stechow has noted, some scholars make that assumption.[9] Horst Gerson wrote: "It seems . . . that Rembrandt sold his pupils' work," referring to a document that indicates Rembrandt sold paintings by Ferdinand Bol and Leendert van Beyeren; Gerson went on to ask, "Did he overpaint them, did he sign them?" Gerson seems to have felt those questions deserved the answer yes, although he offered no evidence. The ordinary gallery-goer might imagine that a Rembrandt signature on a painting offered some assurance of authenticity, but scholars often dispute these warranties. Stechow is irked by Gerson's questioning of the signature on the *Portrait of a Young Student*, now in the Cleveland Museum of Art, which Stechow says is "perfectly genuine and has been confirmed by renewed laboratory investigation." Gerson mentioned another connoisseur's attribution of this painting to Carel Fabritius and was reminded of early pictures by Aert de Gelder and Barent Fabritius; he concluded that "an attribution to Rembrandt is probably not right." Stechow writes caustically: "Thus we have here the 'probable' elimination of the artist who signed the picture in favor of a possible attribution to three totally different artists, one of whom was almost a generation younger than the two others. . . . If signatures are of no consequence, what do we have in the absence of other doc-

umentation? One will have to answer this question with one word: Opinions."[10]

The RRP has discounted several works with Rembrandt signatures and monograms that appear utterly similar to those on works that the team does not question. Gary Schwartz judges the authors of the *Corpus* as dismissing technical evidence and "applying standards of quality connoisseurship" when they write about one such signature on a rejected picture that "the shaping of the letters does not seem spontaneous, and does not carry conviction."[11]

A number of those who worked alongside Rembrandt have had recognition for some time. Jan Lievens, his contemporary and colleague during his first years in Leiden, was praised as Rembrandt's equal by Constantijn Huygens. Gerard Dou, perhaps Rembrandt's first pupil, soon developed his own fine, polished style. The training of another early apprentice, Isack Jouderville, is documented by receipts for his tuition fees from 1629 through 1631, but his identified work has no individual brilliance. Govert Flinck, among Rembrandt's most talented students, painted at least one portrait that was sold as a Rembrandt, but he went on, as did Ferdinand Bol and other pupils, to achieve his own patrons and, indeed, great prosperity. Carel Fabritius and Nicolaes Maes were two of the brightest graduates of the Rembrandt workshop, and the work of Fabritius in particular shines in an independent, idiosyncratic light.[12] Some pupils, such as Jan Victors, who studied with Rembrandt in the 1630s, took on the Master's subject matter, motifs, and attitudes, but generally failed to instill energy or expression in their works.[13] Rembrandt's last pupil, Aert de Gelder, went on painting in the later, broad-brushstroke manner of his teacher, using a similar closetful of costumes and weaponry—possibly an act of reverence, although de Gelder's own affectionate personality comes through in many of his pictures.

The effort to distinguish the work of student from that of teacher was pioneered in this century by John Van Dyke. For him the Rembrandt oeuvre was a giant snowball, which he intended to unpack. He reattributed the great *Danaë*, in the Hermitage in St. Petersburg, to a pupil named Gerrit Willemsz. Horst; various *Saskia*s to Govert Flinck; the *Woman*

Bathing, in the London National Gallery, to another pupil, Gerbrandt van den Eeckhout; the *Sibyl*, at the Metropolitan in New York, to Willem Drost; and *The Man with the Golden Helmet*, in the Berlin Gemäldegalerie ("a masterpiece that suggests Rembrandt in not the smallest way"), to Aert de Gelder.[14] Although Van Dyke visited the Frick Collection, saw the 1658 *Self-Portrait*, and allowed it to Rembrandt, for unexplained reasons he did not refer to *The Polish Rider* one way or another. More recently the German scholar Werner Sumowski has brought forth a series of detailed volumes on the works of the Rembrandt school, illustrating those he believes to be by Rembrandt's pupils and followers; Sumowski has been criticized for failing to make specific attributions in regard to many of the pictures, for example *The Man with the Golden Helmet*.[15] Ben Broos of the Mauritshuis has written an essay about his own preliminary work examining the documents and sources about pupils, and has compiled a fairly comprehensive list of their names.[16] Out of this sort of endeavor has developed greater knowledge of the careers and artistic personalities of some of the pupils—"personality" being a term favored by modern connoisseurs, and intended to connote the sum of identifiable characteristics to be found in an artist's work. Even if, occasionally, one might be tempted to think that interest in minor seventeenth-century Dutch painters is growing in proportion to the numbers of fledgling art historians, it is still the case that names are known of artists of that time who at present have no works credited to them. Fairness to their ghosts might seem to justify attempts to connect them with paintings they created.

Between those who say, "Rembrandt did it," and those who reply that no, such-and-such a pupil did, lies a middle ground, which doesn't achieve much prominence, although now and then an art historian may draw attention to it. One such is Arthur Wheelock. His view is that there may have been a good deal of collaboration between master and assistants. Wheelock points out that in the inventory made of Rembrandt's collection in 1656, at the time of his insolvency, seven paintings were described as "reworked by Rembrandt." He believes that Rembrandt may have asked a specialist in depicting lace to assist in some portraits. No documents have been found to prove such a collaboration, but Rem-

brandt is known to have been influenced by Rubens—his style, his way of life, his fame—and may well have managed his workshop in the manner in which Rubens did; for instance, he may have hired graphic artists to make prints after his compositions. According to Wheelock, "We know that Rubens frequently collaborated with his assistants. I suspect that Rembrandt did as well, and probably at all phases of his career. Lievens, Flinck, Bol, van den Eeckhout, and de Gelder are all distinguished artists from Rembrandt's orbit who could well have worked on paintings with the Master." Wheelock notes that it is hard to identify Flinck's work done while he was in Rembrandt's workshop—in fact, no works are attributed to him that date before he had set up on his own.

Collaboration raises questions about the term "authentic." "What did authenticity mean in the seventeenth century?" Wheelock asks. "Are we applying twentieth-century criteria to Rembrandt's work?" One work traditionally attributed to Rembrandt that may illustrate this gray area is *The Vision of Daniel*, a wonderful painting in the Berlin Gemäldegalerie. It was accepted by Bode and Bredius, but is thought by Gerson and Sumowski to be the work of a pupil. Sumowski thinks that Carel Fabritius may have been the painter, and that there may have been some retouching by Rembrandt. To my eye, a number of features are very Rembrandt, including the bent right foot of the kneeling Daniel, the background hillside, and to the right what appear to be loose rocks on the edge of the chasm. The catalogue of the recent Berlin/Amsterdam/London exhibition based on the RRP's work attributes the painting to Willem Drost.[17] However, "Rembrandt and/or Studio" is how another catalogue—for a show in Groningen—puts it.[18] Perhaps we need to be able to conceive of a painting as an authentic product of Rembrandt & Company.

For the time being, however, the Rembrandt Research Project does not seem sympathetic to this catholic view. It has examined two portraits in Vienna, which many experts regard as a pair, and has accepted one and rejected the other—the rejected picture being one in which Wheelock is ready to see a good deal of pupil work. Josua Bruyn, moreover, finds little similarity in the operations of Rembrandt and Rubens: "Where Rubens frequently touched up student work, it was rarer for Rembrandt to do this. He may of course have left secondary passages to assistants, but the

position of pupils was different in his workshop from what it was in Rubens's. Rembrandt's advanced pupils produced their own work." The authority with which Bruyn speaks is diminished only when one sets his words alongside Wheelock's, and realizes that another expert does not agree with Bruyn at all.

Restorations

A SEPARATE set of questions concerning authenticity arises from a form of collaboration that Rembrandt may never have envisaged: work done on a painting long after it left his studio. No 350-year-old painting can be said with any conviction to look the way it did when the artist ceased to apply paint and varnish to it, with or without assistance. Different colors have changed in different ways because of exposure over time to light and air, to dryness and damp. Varnishes age and may appear to camouflage the artist's purpose, although it should be remembered that the artist fully intended to use the original varnish; it had a purpose in muting and unifying various colorful effects. By the nineteenth century, many Rembrandts were famous (or notorious) for their darkness. They were often framed, hung, and lit in such a way that this quality was exaggerated; *The Night Watch*, for example, was displayed in 1875 in Amsterdam in a manner that the French critic and painter Eugène Fromentin thought made "it look still more smoky than it really is."[1] Ruskin, for

one, couldn't stand Rembrandt, because of his paintings' "diffusion of gloom."[2] But the darkness that time added to the strong chiaroscuro of many Rembrandt paintings may well have been cleaned away in the last twenty years. What might have seemed an authentic Rembrandt on the strength of its melancholy, blurred dark-brown patina may need to be judged afresh as a painting with vivid reds and oranges and distinct glazes. A recent cleaning has revealed bright pinks in the *Old Man in Prayer* in the Boston Museum of Fine Arts. We ought to remind ourselves that paintings seen by past generations of connoisseurs often look a good deal different now.[3]

Artists customarily feel a deep-in-the-bone horror at the work done by restorers. Delacroix declared that "each so-called restoration is an injury far more to be regretted than the ravages of time."[4] After the cleaning of a Rembrandt in the Louvre a century ago, Daniel Halévy, a friend of Degas, said the loss of shadows in the painting had left it deflowered, robbed of mystery. Degas was equally infuriated. "What do I want?" he demanded. "I want them not to restore the paintings. If you were to scratch a painting you would be arrested. . . . Time has had to take its course with paintings as with everything else, that's the beauty of it. A man who touches a picture ought to be deported. . . . To touch a Rembrandt!"[5]

Of course, museum directors tend not to share this absolute respect for the artist's product as time has encrusted it. Would the public continue to come and look at faded and grimy pictures? And museums continue to employ specialists to clean and make good. The restorers who bring about these changes have, like other experts, a range of skills, talent, and sensitivity. Some believe in holding on as best they can to the status quo; some believe in trying to return the work to the state in which, the restorer trusts, it was originally. John Brealey, the conservator at the Metropolitan Museum in New York, who has a reputation for truly conservative care, has said: "Every painting has a finite life. There is no such thing as permanence. Time has wrought havoc on every painting in every gallery in the world. There isn't one that looks the way it did when it left the artist's studio. There's hardly a painting left with something of its original surface. . . . No one makes allowances for the great changes that have taken place in paintings."[6] Some Rembrandts have been more "done over" than

others—so much that there may be little in the paint one sees on the canvas that was applied by either Rembrandt or his assistants. *The Night Watch* is a case in point. Gary Schwartz, echoing Brealey, says, "Who knows if what's left on the surface of it bears any relation to the way it looked when Rembrandt finished it."

The Polish Rider has been restored and cleaned a number of times. It probably was given some sort of treatment in Vienna in 1877, and certainly was in Berlin in 1898.[7] It has been relined with canvas on several occasions; this process has somewhat flattened the original impasto. The Frick catalogue refers to paint losses, abrasions, and old tears. A row of nail holes near the top, now filled with gesso, suggests that the picture was once mounted on a shorter stretcher, with, according to the Frick catalogue, "several inches of sky at the top of the canvas folded over out of sight." At the bottom, part of the original canvas with two of the horse's hooves had been lost and—presumably before the painting reached New York—replaced with a strip of coarser canvas about four inches high. On this, the two restored hooves were painted "awkwardly, so that they were seen in profile rather than slightly fore-shortened," with the result that the horse appears to have a conflicting and hence static gait.

Since *The Polish Rider* arrived at the Frick, it has received a good deal of technical attention. In 1935, some missing pieces of its frame were replaced, the corners rejoined, and the gilding touched up. In 1938, before the painting was cleaned, it was closely examined by the conservator George Stout. He wrote: "The principal figure and his horse have escaped the amount of loss and . . . restoration which the rest has suffered"; Stout apparently thought the background had been somewhat damaged and restored.[8] During the first half of 1950, the painting was in the hands of William Suhr, an expert restorer who was at that time the Frick's conservator. It seems likely that no one had looked at the work so closely since it was painted. On his first inspection, Suhr was impressed by "the abominable color of the varnish, a deep brown, which makes the painting all but invisible."[9] The painting was X-rayed, and the canvas in the newer bottom strip was seen to have a coarser weave. After Suhr had removed all of the old varnish, he reported that the danger of damaging the original paint—a danger in every cleaning—was especially acute here: "The reds

of the trousers, cap and harness and the ocher in the bit are very sensitive. It is only common sense to recognize that the friction alone involved in cleaning, repeated over and over again, must in time wear down any paint film." One had to face the choice of not seeing the picture at all or seeing it falsified or running the risk of continuously "skinning" it by such cleaning. Suhr said that the varnish dissolved easily; the colors could then be seen without the falsification of the dark brown film of varnish, dating from the last complete restoration and later touch-ups. And now the losses, tears, and nail holes were visible, as were blemishes and abrasions. The ground could be recognized by the fine white grain in the umber-colored layer, but it was hard to determine the extent of any losses, because of what Suhr called Rembrandt's "skipping brushwork."

Suhr dealt in detail with certain aspects of the painting. The legs, he noted, "look unfinished, only blocked in. It seems to me another of Rembrandt's characteristics that he leaves in many of his pictures parts unfinished; in his portraits, for instance, the hands are often merely sketched in." From the pentimenti he spotted, Suhr noted the following changes: The arrows had been shortened. The bow had been placed half an inch higher. The leg of the rider had been pulled back. The position of the bit had been altered three times. Suhr was uncertain about the "R" in the rock, whether it was part of a signature, or whether it had been put there by Rembrandt. But for Suhr the picture was definitely "a twilight scene." And he had no doubt as to who had painted it: "A characteristic bit of Rembrandt technique is the area just behind and above the fire at the pool. It is an ocher-umber-colored pasty underpaint with a texture like lava flow, glazed with an asphalt-colored tone, which then was wiped off, leaving it in the depth and crevices. Similar areas are to be seen in the [1658] *Self-Portrait* in the sleeves, the Rijksmuseum *Betrayal of St. Peter*, and others." This reaction can be contrasted with Suhr's response to the *Portrait of a Young Artist* bought by Frick as a Rembrandt in 1899, accepted by Valentiner and others, and still listed as a Rembrandt in the 1954 Frick catalogue. Suhr cleaned the picture in 1948 and suggested that it was not by the Master. This suggestion has now been generally accepted; the painting has been removed from the gallery where the 1658 *Self-Portrait*, the *Portrait of Nicolaes Ruts*, and *The Polish Rider* hang,

and is to be seen—only by the Frick staff and their guests—at the top of the stairs that lead to private rooms and offices.[10]

Suhr followed his cleaning of *The Polish Rider* with "retouching and varnishing." What the retouching involved is not spelled out in Suhr's report, but it apparently included the repainting of the two hooves on the newer bottom strip, which vastly improved them in terms of perspective and coordinated the way in which the horse's legs seem to be moving. (A legend in the art world has it that, as one museum curator put it, "Billy Suhr did the bottom four inches of *The Polish Rider*.")

In the years since that major restoration, the painting has had further attention from time to time. In 1957, repairs were made to unspecified damage caused by a leak; afterward Suhr dusted the picture and rejuvenated the varnish with plain rectified turpentine. In 1969, the varnish was again removed, and new varnish and a wax spray applied. In 1980, assistants of John Brealey "spit-cleaned" the surface of the painting and then sprayed it with a single coat of ketone N retouching varnish and a small proportion of benzyl alcohol. Saliva seems to be effective in getting rid of surface grime because of a particular enzyme, ptyalin; a synthetic enzyme has been produced for the purpose which conservators have found less useful. Moreover, saliva is rather sticky and when applied with cotton wool doesn't penetrate a painting in the way water does; water and soaps can cause blanching and disturb a varnish layer. Saliva is thus relatively risk-free, at least when used by experts on paintings that are not flaking.[11]

Rudiments and Documents

A T THE start of his essay "The Rudiments of Connoisseurship," Bernard Berenson lists three kinds of materials needed for the historical study of art and therefore valuable for determining questions of authenticity: (1) contemporary documents; (2) tradition; and (3) the works of art themselves.[1] Let us consider the first in relation to Rembrandt. The documents favored by Berenson were contracts between patron and painter, although he admitted these could be faked and in any case didn't prevent a number of Italian Renaissance artists from handing over much of the contracted work to their assistants. With Rembrandt, as noted before, fewer than a dozen paintings have related documents that help prove he painted them. Among these are the five paintings on the theme of Christ's Passion for the stadtholder Prince Frederick Henry. This commission produced eight extant documents: six letters, a reminder about payment from Rembrandt to Constantijn Huygens, and a payment order from the prince's treasurer in The Hague to the paymaster in Amsterdam. (The

documents prove, by the way, that Rembrandt was extremely well remunerated for this series, at 600 guilders for each of the five paintings, although he asked, unsuccessfully, for 1,200 for the third—and 1,000 each for the fourth and fifth, which he was slow to complete.)

The Night Watch is another painting for which there survive documents dealing with its commissioning and its ownership up to the present. "Just as well," says Gary Schwartz, sardonically. "If judged purely by the methods of the Rembrandt Research Project, it might not make it." Yet contemporary seventeenth-century documents have not in the latest analysis saved from deattribution a painting in the Royal Collection at Windsor. The documents show that this portrait of an old woman, thought to be Rembrandt's mother, was brought from Holland to England in 1629 by Sir Robert Kerr, given to King Charles I, and entered as a Rembrandt in the catalogue of the Stuart collection in the 1630s. X rays have revealed beneath the surface an earlier painted head of an old man, which resembles that of a model used by Jan Lievens and Gerard Dou and, according to Gary Schwartz, also looks like that in a copy by Christiaan Huygens of a lost portrait of an old man by Rembrandt.[2] The RRP, in volume one of its *Corpus*, weighed the evidence regarding the Windsor *Old Woman* and accepted it as a Rembrandt, although from the early 1630s. In volume two, the team decided the documents did not count for much, and reattributed the painting to Lievens.

Among Berenson's categories of materials needed for determining authenticity, documents—if one can find them—would seem to provide the best clues in tracking back from the present to the time in which a work of art was created. In 1968, the philosopher Nelson Goodman suggested that one would not be able to distinguish between the original *Lucretia* by Rembrandt and a "superlative imitation" by simply looking at them, and that "the only way of ascertaining that the *Lucretia* before us is genuine is ... to establish the historical fact that it is the actual object made by Rembrandt." Moreover, Goodman went on, "authenticity in an autographic art"—like painting but unlike music, where there is no such thing as a forgery of a known work—"always depends upon the object's having the requisite, sometimes rather complicated, history of production."[3] Schwartz writes, "I follow Goodman in concluding that the only way of

ascertaining the authorship of an object is to establish the history of its production."[4]

As for *The Polish Rider*, no documents from before 1791 have been found connecting it and the name of Rembrandt. In this, it is like the vast majority of paintings attributed to the Master. Like them, therefore— whatever connoisseurs say so firmly one way or another, and however strongly one feels—it must remain what Schwartz calls "a disputable case."

Scholars' Mistakes

HOW SUCCESSFUL have connoisseurs been in the past at crediting an artist with his own work? Without doubt, many cases of mistaken attribution hang undisturbed on the walls of museums and in collectors' houses the world over. Whether from inertia or lack of scholarly interest, the little plaques have retained their traditional names. Yet a shakeout is always possible: along may come a Morelli, a Berenson, a Haak, to say, "This just can't be right!" And new attributions are made. A Raphael is given to Perino del Vaga. A painting in the Boston Museum of Fine Arts once labeled Hendrick Terbrugghen has recently been given to Rembrandt's most brilliant pupil, Carel Fabritius, currently known for only eight paintings. Scholars invest much of their lives in the study of a painter, and naturally seek out work of that artist that requires recognition. Not surprisingly, the cliffs and crevasses of attribution are littered with the bodies of connoisseurs who have taken too bold a step, perhaps

prodded by dealers and market forces, in the way Berenson sometimes was by Duveen. In 1930, W. R. Valentiner organized in Detroit an exhibition devoted exclusively to Rembrandt. Seventy-eight paintings were hung. Of these, writes Gary Schwartz, "fewer than one-third...have any claim to be by Rembrandt."[1] Valentiner was the protégé of Wilhelm von Bode, who "discovered" many supposed Rembrandts, including *The Man with the Golden Helmet*, which was revered by such distinguished Rembrandt scholars as Jakob Rosenberg.[2] This painting until recently had a spotlit place in the Berlin Gemäldegalerie, where hundreds of thousands of visitors admired it as a Rembrandt. Schwartz, with pardonable *Schadenfreude*, comments: "It was after all the good Berlin connoisseur Bode on whose authority the Rembrandt label was attached to the painting in the first place. We can go further and say that every work of art with a questionable label was given that label by a connoisseur whose age thanked him or her for having restored to a neglected work its rightful glory."[3] Bode also went overboard for *The Mill*, which he called "the greatest picture in the world," and for which, in 1911, P. A. B. Widener forked over the largest amount until then paid for a painting. Now in the National Gallery in Washington, the work is no longer considered by most experts to be by Rembrandt.

Connoisseurs may reply that they aren't alone in making such mistakes. Sir Joshua Reynolds thought that Rembrandt was not the painter of *The Night Watch*, which to him "seemed...to have more of the yellow manner of Bol."[4]

Admissions of mistakes are infrequent. Some scholars, like politicians, change the subject. Some simply stay silent. Some stick to their guns and, perhaps rightly, question the soundness of the arguments being used against them. It is not often that a painting itself provides sufficient proof of mistaken attribution, as did the *Jacob's Dream* at the Dulwich Picture Gallery, which was hailed as a Rembrandt by William Hazlitt but when cleaned in 1946 revealed the signature of Aert de Gelder.[5] I was delighted to hear Egbert Haverkamp-Begemann nobly admit that he had been mistaken in attributing to Rembrandt a drawing at the Museum Boymans–van Beuningen in Rotterdam, when he was a curator there. He has now

come to agree with other experts who say it is not by Rembrandt. He is interested in how the breach in his confidence was made and in the difference in his perception of the drawing, before and after his change of mind.

It might be asked at this point, and not only by the nonspecialist: In what way do these mistakes matter? How important is it for our appreciation of art that we know exactly who the author of a painting is? Most of us can no doubt summon up the recollection of a picture that has attracted us and even moved us, of whose creator we know little or nothing. One—among several—in my experience is a mid-seventeenth-century painting in the National Gallery in London called *The Ark of the Covenant*. It was painted, so the label says, by Sébastien Bourdon—who, a dictionary of artists I have just consulted tells me, was a Frenchman who worked somewhat in the manner of Claude and Poussin. But in fact I have looked at this painting many times with pleasure without knowing anything about Bourdon, and could almost be lured into saying that it wouldn't make a lot of difference to me if *The Ark of the Covenant* were ascribed to another painter, Poussin for instance, or even to no particular painter at all.

Yet I know this is not so. For one thing, it certainly helps in sorting through the filing systems of the mind that there is an artist's name to attach to a picture, whether that name is Bourdon or Bonnard or Bob Smith. A completely anonymous painting, no matter how fine, is perforce going to stand a better chance of getting lost in the merciless clutter of memory. Moreover, our sense of an artist is built up of encounters with his or her works, and if some of those encounters are removed—wiped clean from our experience—we are left with a reduced idea of the artist. The Rembrandt who did not paint *The Polish Rider* is a different artist from the Rembrandt who did. In addition to the already noted sense of justice we feel bound by, which makes us want to give their proper due to the creators of works of art, we are driven to attempt to see the past as it really was. This, in the field of painting, means making an honest effort to attach to painters all the works they actually painted—which in turn means that any other painting I encounter that is given to Bourdon (to stick to our present example) is going to have an impact on my presently not very substantial idea of him, just as it would if *The Ark of the Cove-*

nant were removed from his authorship. (Poussin would certainly gain in my estimation if he were given this picture!) And I have to admit that I would—given world enough and time—much rather know more about Bourdon than less, the next time I stand there in the National Gallery.[6] To admit the contrary, of course, would deny the raison d'être of art historians and connoisseurs.

A Team and Its Critics

ONNOISSEURSHIP BY a team is a newish practice and has not been widely examined. The record of the RRP to date suggests that bold decisions of deattribution, and even changes of mind, as in the case of the Windsor *Old Woman*, may be made more easily by a group. In the preface to volume one of the *Corpus*, we read that "a closely knit group tends to feel [fewer] doubts or hesitations than [does] an individual. The dilemmas of a team member were occasionally washed away by the cogency of the others."[1] From my own experience as a member of committees, I know that they function most smoothly when they are in pursuit of an agreed-upon object, when the members are generally like-minded, and when the chairman can steer the discussion skillfully or forcefully around disputed factors to what he assumes is a shared goal. Thus, at the start, there is an advantage in terms of "getting through the work" in not admitting to membership anyone who has a different basic approach to the

matter at hand. A common training, education, and language may seem vital qualifications for a team that is to be "closely knit."

The gatherings to welcome back the Project's pair of investigators from their field trips are now long in the past, and the weekly lunches were discontinued some time ago. Josua Bruyn says that "as the effort became less common, there was less need for meetings." The pens writing the drafts of the *Corpus* have in recent years been largely in the hands of Bruyn and Ernst van de Wetering, and it is Bruyn's personality that most close observers find stamped on the first two volumes. These demonstrate that he believes in a rigorous, scientifically based approach to connoisseurship and that he tends to be demanding. (A fellow art historian who once walked through a museum with Bruyn remembers that every time they paused before a painting, Bruyn found a fault in it.) However, although clearly he has been the team leader, Bruyn insists that decisions about attribution, which he admits can be "delicate," are made by the entire team. As he told a Dutch reporter, "This means that the responsibility lies in the hands of the committee members and does not fall on one individual."[2] It also means that in dealing with people upset by RRP decisions, the team as a whole shoulders any blame or abuse.

As the preface to volume one of the *Corpus* admits, a different psychological process may obtain when several connoisseurs are involved in making decisions about attributions. *The Burlington Magazine* perceives a disadvantage of this in the team's conclusion to "the complicated question of the various representations of the Raising of Lazarus by Rembrandt and Lievens. [The members of the team] dispose of the inconvenient date of 1630 on the British Museum drawing by arguing that if it was dated by Rembrandt at all this was done only later and then incorrectly. The drawing itself provides no support for this conclusion. In such instances, it is perhaps fair to detect something of the effects of group psychology."[3] Bob Haak, one of the pair who examined *The Polish Rider* in 1969, says, "You are prepared to take risks when you have a companion. If you are riding a bike alone and you come to a red light, you stop. But when you have a friend riding with you, you may give each other the necessary daring to ride through." Doubt is infectious, and it not only spreads

from person to person but intensifies as it does so. Ernst van de Wetering says there is danger in pointing out a weak spot in a painting to a colleague, for he will then point one out to you, and you will find another to show to him, and so on. They may ride together through Haak's red light.

Even so, the team qua team has its defenders. Michael Kitson, a British art historian who doesn't support all the Project's deattributions, observes: "A team means there is less liability in a member's having an off-day—which a connoisseur on his own could have with more serious effects." Egbert Haverkamp-Begemann, who also disagrees with some RRP verdicts, believes that the team practices more than just connoisseurship by majority vote. "Their findings are the result of much debate among collocutors, among individuals who bring different areas of knowledge to the discussion. But the discussion requires that those taking part in it have similar responses to visual experiences—say, to the shadows in the eye sockets of Rembrandt portraits. Unless they all observe the same things there, when they are talking over the value of such characteristics, the discussion is meaningless."

The members of the team feel strongly that their method is an improvement over the way connoisseurs have operated in the past. Although they write, modestly, in volume two of the *Corpus*, that their views are not the last word, they are aware that the very existence of the work, as well as its size and gravitas, gives the impression of detailed and determined judgment. In regard to the detail, Haak says that there would have been no point in simply following Bredius in choosing many paintings as Rembrandts and not saying why one had picked them. In regard to the determination, Bruyn, the team leader, refers to the *Corpus*, with a pleased chuckle, as "a book of rather firm decisions." And he is quick to defend his team against the criticism that despite their claims to comprehensive examination of paintings and use of modern scientific aids, he and his colleagues are ultimately as subjective as previous connoisseurs. "Our decisions," he says, "are the result of five of us looking very carefully at hundreds of paintings attributed to Rembrandt, and our judgments are therefore at the least intersubjective." Van de Wetering thinks the team practices a profitable form of group connoisseurship, but he doesn't pretend the members always arrive at a consensus; any one of them may

never be quite as convinced as the others about a particular decision, and it would be unscholarly to suggest otherwise. In volume two of the *Corpus*, in fact, van de Wetering expresses a minority opinion about several paintings.

For all of the argument and passion it produces, the world of Rembrandt scholarship and expertise is not large. It contains probably at any single time forty or fifty people who find in it some of their livelihood or principal motivation. Of these, perhaps twenty are the essential movers and makers. Included in this highly committed inner circle are the RRP members Josua Bruyn, Bob Haak, and Ernst van de Wetering; the museum officials Arthur Wheelock (in Washington, D.C.), Walter Liedtke (in New York), Christopher Brown (in London), Peter Sutton (in Boston), Christopher White (in Oxford), Peter Schatborn (in Amsterdam), and Ben Broos (in The Hague); and the academics Werner Sumowski (in Stuttgart), Seymour Slive (at Harvard), Svetlana Alpers (at Berkeley), Egbert Haverkamp-Begemann (at New York University), and David Freedberg (at Columbia). One would name also a few less prominent but equally vital scholars, such as the Dutch archivists Isabella van Eeghen and Sebastian Dudok van Heel, and the Metropolitan's research fellow Maryan Ainsworth. And certainly not to be left out are Gary Schwartz, who has been employed in part as a publisher, and Julius Held, although he long ago retired from teaching.

It is a world in which relations are remarkably cordial on the surface; underneath, one sometimes glimpses rapier or knuckle-duster. Scholar X in a letter refers warmly to his friends and colleagues in the field of Rembrandt studies. One of those friends, however, says privately that X gets terribly worked up about what Josua and Ernst are doing. Another scholar says, "So-and-so reviewed my last book very nicely, but he's really a dreadful fence-sitter." Another, upon hearing I am on my way to see Y, says, "For God's sake, don't tell him you've talked to me first, or he'll make a point of finding out what I said and then disagreeing with it." Most of those who aren't on the team introduce conversation on the subject of the RRP with, "I admire the members of the Project very much," or "It's a most courageous, painstaking effort," before getting down to the

nitty-gritty of disagreement. The Rembrandt scholars appear at symposia together and generally make charming introductions of one another to the listeners. (Not long ago, however, van de Wetering heard himself being described by a professor to a California audience in very succinct terms: "This is Professor van de Wetering," she said, adding, as if it were all he had going for him, "He is a native informant.") They review one another's books—who else can?—in pieces that often take a year or so to write and that appear in *Oud Holland*, *The Art Bulletin*, the London or New York *Review of Books*, *The Burlington*, or *Apollo*. Scholarly camaraderie generally softens the rougher edges of argument. "A very thoughtful new book," writes Peter Sutton of Svetlana Alpers's *Rembrandt's Enterprise*. "However, many may be uncomfortable with . . ."[4] Gary Schwartz feels "deep discomfort" about Alpers's book, about its "extreme claims" and "ignoring of historical facts," but in his last paragraph admits that he may have been "too harsh" and that the book contains some "positive contributions."[5] One has the impression that Rembrandt scholars usually turn first to the bibliographies and indexes of their colleagues' works, to see what mention they themselves have received in text or footnotes. They are not always very respectful of the dead. While Morelli was still warm in the grave, Bode attacked him as a "quack doctor [who] extolled his method with an air of infallibility."[6] What are now thought to be the gaffes of Bode, Valentiner, Rosenberg, and Bredius are held up for inspection, if not derision. Van Dyke is disparaged and dismissed as a crank. To the lay observer, much of this activity can seem incestuous or forbidding; theories and apparatus are erected which may provoke or illuminate but which often form barriers between the non-scholarly admirer of Rembrandt's art and the art itself. The art, after all, came first; all criticism is parasitical.

Most Rembrandt experts agree that the Rembrandt Research Project deserves praise for diligence. "The thoroughness of the scholarship is remarkable," says *The Burlington*, while daunted by the number of words in the *Corpus*.[7] Arthur Wheelock says the team should be given credit for amassing tremendous amounts of information, for helping dramatize questions of authenticity, and for bringing people to look at Rembrandt's work afresh. Gary Schwartz feels that Bruyn, Haak, and van de Wetering

are all "good people who have made fine contributions to art history." Most of the team's attributions to date are not the subject of argument. But the rumpus caused by the Project continues to grow.

In the Netherlands, the team has been criticized in the press for not keeping people informed about its findings in the years between publication of *Corpus* volumes. Public funds have gone to the RRP by way of the Netherlands Organization for the Advancement of Pure Research, and in the first years of the Project other Dutch art historians may have felt some jealousy, because the RRP seemingly monopolized state subsidies. Yet according to Josua Bruyn, the state handout has paid only for necessary secretarial help, travel expenses, photography, and occasional substitutes for him and van de Wetering at university lectures and classes. No salaries have been paid to the Project members, who all had their own jobs. According to Bruyn, "The Project has cost very little in relation to more than twenty years of effort." Now, in fact, other Dutch art historians tend to feel pity rather than envy for the team; they see it tied to a demanding task that clearly will go on and on.

Outside its homeland, criticism of the RRP coalesces around several issues. That most of the critics *are* outside the Netherlands may reflect the hackle-raising factor that the team members are all Dutch. Arthur Wheelock, for one, thinks that if the Project had more of an international cast it might have fewer problems. The team's method, breadth of view, and consistency are among the concerns. A number of critics, including Wheelock, Christopher Brown, Walter Liedtke, Peter Sutton, and other curators whose museums have had works deattributed by the RRP, feel the *Corpus* categories of A and C are too firm, and that there should be more B's—that is, paintings about which a definite verdict cannot be given. (In the second volume of the *Corpus*, the team was unequivocal about 62 paintings as A's and 37 as C's; only one was a B.) Liedtke believes the system should be modified: "The 'A' pictures should be absolutely indisputable works; the 'C' pictures should be indubitably deficient; and the 'B' paintings should be numerous, with a lease in limbo, where they can be protected by penetrating if inconclusive scholarship from pungent press reports or embarrassing moments in an auction house."[8]

To some observers, a characteristically Dutch belief in certainty seems

to pervade the Project—a confidence that right and wrong, true and false, can be definitively determined. For Liedtke, the team's approach to Rembrandt "misconstrues the fundamental nature of connoisseurship, which is a kind of criticism, and when criticism reaches its final destination, arriving at absolute conclusions, it becomes academic doctrine, and it dies."[9] To Wheelock, the members of the Project have, "as a basis of their pronouncements, a conviction that Rembrandt's genius is clearly distinguishable from the efforts of his contemporaries." They have not always managed to persuade others to share this conviction; indeed, as Svetlana Alpers has remarked, "instead of isolating Rembrandt's manner, the team has called attention to its diffusion."[10] Christopher Brown feels strongly that the RRP has expectations of Rembrandt that are often too high: his work should be always perfect, and if it isn't, it is credited to pupils or followers. Or as Wheelock puts it, "Whereas Bode welcomed Rembrandt's stylistic eccentricities as confirmation of his artistic genius, these Dutch art historians tend to see them as justifications for rejection." David Freedberg agrees: "The *Corpus*, for all its merits, has a false aura of objectivity. It reflects the team's supposition that it can reduce everything to a science. But the RRP remains in the end subjective, like previous connoisseurs."

Maryan Ainsworth is critical of the team for not being consistent in its way of looking at pictures: a painting owned by a private collector may have been examined in a manner quite different from that used for a painting in a museum, where X rays and paint samples may be provided. She and Wheelock both think the RRP has not been sufficiently open to what Rembrandt's drawings and etchings tell us about his paintings, since similar features and parallel techniques are to be found throughout his works, whatever the medium. Although she continues to make only modest claims for autoradiography, Ainsworth says the Project is denying some of the serious evidence about his paintings that autoradiographs have provided, where Rembrandt's drawing and etching techniques would seem to be demonstrated in various exposed strata. The network of paint strokes is often similar to the network of hatching that Rembrandt made with an etcher's needle. The energy with which he sketched out the basis of a portrait, or decisively executed serious changes, is to be

seen in the autoradiographs of paintings just as it is in Rembrandt drawings—energy that appears to have been part of his thought process. Peter Sutton is disturbed that the Project is now arriving at verdicts based on reports made by the pairs of scouts at least twenty years ago. He worries that although some paintings may have been revisited by individual members of the Project, not all have been looked at again and discussed on location by the same pair who saw them originally. In fact, none of the paintings to which Rembrandt's name is attached at the Boston Museum of Fine Arts has been reexamined at all.

A fundamental flaw in the RRP approach may appear in the team's assumptions about the size of Rembrandt's oeuvre. Professor Ad van der Woude at Wageningen Agricultural University in the Netherlands has estimated the likely numbers of Dutch paintings made in the seventeenth and eighteenth centuries, and the average number painted by individual artists in order to make a living. He reckons that the production of between one and two paintings a week was needed in order to earn a decent income. Samuel van Hoogstraten and Arnold Houbraken both recount tales of a competition among the artists Francois Knibbergen, Jan Porcellis, and Jan van Goyen to see who could paint the best picture in one day. In 1615, Porcellis contracted to deliver forty seascapes in twenty weeks. The painter Michiel van Miereveld produced, according to Houbraken, some five thousand portraits in a working life of some fifty years. For Rembrandt, important commissions such as *The Night Watch* might have taken months, but a conservative estimate is that he painted around twenty-five pictures a year during a working life of forty-five years or so—thus, a total of about a thousand paintings. Rembrandt was nearly always famous; the chance that some of his works are lost is therefore less than that for more modest works by other artists of the time, although some may have disappeared or, like Mr. Hope's, been destroyed. But it doesn't seem unreasonable to assume that six hundred Rembrandts are extant.[11]

The very basis of the Project is attacked by Gary Schwartz. Schwartz—in his early fifties—is in a unique position, being both insider and outsider, an American born in Brooklyn, who, after studying art history at NYU and Johns Hopkins, went to the Netherlands in 1965 to do re-

search. Formerly a publisher of art books and, for many years, of the art history journal *Simiolus*, Schwartz is married to a Dutch art historian and lives in a patrician house built in the 1720s on the banks of the Vecht River in the village of Maarssen, half an hour by train from Amsterdam. He is a tall, imposing man with a serious but friendly manner. In his first years in Holland he did much translating and editing for art scholars, including the Rembrandt expert Horst Gerson. Schwartz says that Gerson, a traditional connoisseur but also something of an iconoclast, felt that the team approach to remaking Rembrandt's oeuvre was not a sound one. "He tried to talk them [the RRP] out of it." Schwartz has put his own interest in Rembrandt on display in his book on the artist. With help from archivists, he has looked into hundreds of obscure contacts and connections of Rembrandt's. He says he has attempted to avoid "the art historian's sin of trying to interpret [an] artist's character on the basis of his work."[12] (This statement begs the question: Is it a sin? To this my answer would be, Not always; in other words, the work is bound to cast light on the artist's character but of course should be taken together with such documentary evidence as exists.) At the end of his book, Schwartz plumps with surprising eagerness for a harsh view of Rembrandt as "an untrustworthy character" with "a nasty disposition,"[13] a view that Schwartz maintains is supported by written evidence but that the totality of Rembrandt's work surely does not lead us to—if we are allowed to take it into account.

Here Schwartz seems to be going along with gossip about Rembrandt's avarice, started perhaps by pupils and repeated by the early writers Houbraken and Jean Baptiste Descamps, and similar to that heard about many other painters with students. Schwartz takes the side of those who talked to a few pupils who, as some pupils will, thought the Master was a bully. (Antony in *Julius Caesar* said it for all time: "The evil that men do lives after them, / The good is oft interred with their bones.") Schwartz, along with others, is ready to find Rembrandt's behavior deplorable in the case of the nursemaid Geertje Dircx, who sued the artist for breach of promise and was imprisoned in a house of correction in Gouda, although the available documents may shed only a very partial light on the affair. It might be noted here that the extant documents per-

taining to Rembrandt's life do not necessarily assist a balanced view of his character; many of them have to do with financial or legal difficulties. Long stretches of his career that may have been less stressful, happier, or simply more routine seem to have gone undocumented and may therefore be less acknowledged. A basic scientific—and, I would have thought, biographical—principle is that absence of proof cannot be taken as proof of absence.

On the other hand, Schwartz often describes Rembrandt's work in a manner to which I, for one, respond—as, for example, when he writes of works by the teenage Rembrandt as "airless, aggressive compositions in harsh colours,"[14] or when he is conveying the overwrought, melodramatic quality of some of Rembrandt's first mature paintings. And he has the further interest of being an art historian who is unusually involved in the sociology and psychology of the profession. Schwartz sees the members of the Rembrandt Research Project as individuals subject to peer pressures and to the constraints of being in a self-selected, somewhat insulated group; figures in the hierarchy of Dutch art historical research, they are subject to common dictates of loyalty, taste, and behavior. He admits that despite his admiration for the team members as scholars and teachers, "there has been a lot of tension between us for a long time." In Schwartz's opinion, the members of the RRP are "in over their heads, intellectually, methodologically." To him their work began in a sort of generational reflex: "They were angry young men needing to push away from the judgments of the previous generation of scholars." (He admits to similar impulses.) He believes the RRP's overwhelming interest in attribution and authenticity diminishes the importance of many other complex factors involved when people look at a work of art, and he finds no advance in the substance of connoisseurship—only in style—in having "interlocking circles of specialists" rather than the single, old-fashioned, encyclopedic connoisseur. Subjectivity will still be influential, in spite of the adoption of scientific techniques in an attempt to "objectify attributions." "How else but subjectively," Schwartz asks, "can one pair, by whatever means the occasion seems to call for, an object of uncertain status with a historically untenable category? To do this by committee rather than individually, to consult autoradiographs and thread counts in addi-

tion to qualitative criteria, to average out the results by a process of consensus cannot change this. In fact, such developments will probably only aggravate things as art historians enlist the aid of scientists in the search for chimeric proof of authenticity, defined by stricter and stricter standards."[15]

For that matter, because the RRP is trying too hard to arrive at a consistent body of work for Rembrandt, its published volumes come across as authoritarian, *categorical*, when in fact it may not be possible, after three and a half centuries, to take so firm a stand on the question of authorship of paintings that have often been considerably damaged, restored, or copied. "The authority behind the *Corpus* dares the reader to attack it," Schwartz says. "I resent the assumption that I expect simple yes-or-no answers to questions that may be unanswerable on present evidence."

Monday Mornings

MANY EXPERTS are less reluctant to pick up this particular gauntlet thrown down by the RRP. In fact, a specific area in which opposition to the Project has become manifest is that of the paintings the *Corpus* has relegated to its C category. Although, as noted before, a good number of these unaccepted works arouse no dissent—many are judged by most contemporary experts to have no place in the canon—a sufficient number are controversial enough to call into question the accuracy of the Project's decisions. Among numerous examples, the so-called Beresteyn pendants in New York's Metropolitan Museum particularly illuminate the arguments on both sides. These pictures, which once belonged to the Beresteyn family in Holland and were given to the museum by Mrs. H. O. Havemeyer, had hitherto almost invariably been credited to Rembrandt's fast-climbing early Amsterdam period. (In 1631 and 1632, the artist—"an overworked young man," in Arthur Wheelock's words—completed forty-six portraits, including a portrait of Princess Amalia van Solms, the

stadtholder's wife. Another was the portrait of Nicolaes Ruts, which Christopher Brown calls "an outstanding example of the portrait style which proved so successful that, according to Houbraken, sitters had to beg Rembrandt to paint their portrait, 'and then add money.' "[1] Today the Ruts portrait hangs in the Frick between the 1658 *Self-Portrait* and *The Polish Rider*, and receives scant attention.)

Some scholars looking at the Beresteyn pair—a middle-aged couple whose names are not known, wearing elegant dark clothes with lace collars and ruffs—have seen differences in the quality of the two portraits. Two experts, Horst Gerson and Hubert von Sonnenburg, have accepted the man as being by Rembrandt and attributed the woman to his workshop.[2] The RRP has rejected both; it says that the quality of both paintings is below the level expected of Rembrandt.[3] In the case of the man, his cloak hangs unnaturally, his flesh lacks plasticity, and his eyes are painted in a way that is uncharacteristically "coquettish" (ill. 16; they look anxious to me). As for the woman, the team regards one of her arms as awkwardly foreshortened. Moreover, the brushstrokes are broader than any the team finds in other Rembrandts of this period. Ernst van de Wetering apparently has concluded that the pair are by Rembrandt's pupil Isack Jouderville.

However, the RRP has run into decided opposition here. Walter Liedtke at the Metropolitan calls the attribution of the Beresteyn woman to Jouderville "implausible" and of the man to Jouderville as "outrageous." And he writes that certain sections of the *Corpus* catalogue entries, such as that commenting on the Beresteyn man, "read more like arguments than analyses—scholasticism as connoisseurship."[4] David Freedberg considers the Beresteyn deattributions an example of the way in which the team, despite its declared aims, takes refuge in old-fashioned connoisseurship and fails to come to terms with convincing up-to-date scientific evidence. The Metropolitan's own investigation of the Beresteyn pair, conducted by Maryan Ainsworth, John Brealey, Egbert Haverkamp-Begemann, and Pieter Meyers, used autoradiography and concluded that "close examination of the brushwork and working procedure of these paintings reveals Rembrandt's characteristic technique in both." The two portraits show "a consistently linear approach. In the au-

toradiographs, this approach is found not only in the distinct undulating contours of costume, but even in the features of the face, which were outlined with vermilion strokes."[5] Brealey, whose father was a portrait painter, once suggested to *ARTnews* that the reason Rembrandt did a less satisfactory job with the Beresteyn woman was simple: "She was a dreadfully boring woman, and you can see it looking at her face. It was one of those commissions that portrait painters have to do to earn money."[6]

Similarly disputed is the 1643 portrait known as *A Bearded Man in an Archway*, which, it seems, will be put among the C's in the next volume of the *Corpus*, but which Haverkamp-Begemann and Christopher Brown are certain is an A. One famous painting known to have been rejected by the team, though not yet treated in the *Corpus*, is *The Man with a Golden Helmet* in Berlin. But in its case, scholarly opinion has quickly come around to share the judgment of the RRP that the painting is by a pupil or follower, perhaps Ferdinand Bol. One reason for this common feeling may be that the Gemäldegalerie has also gone in for autoradiography, and has decided on its own that the painting is not by the Master.

A central issue in the case of the disputed C paintings is the consistently high standard expected of Rembrandt by the RRP. It is on this point that the Project and many of its critics most forcibly divide. Arthur Wheelock thinks the team has succumbed to a view of Rembrandt as a genius who worked at levels his contemporaries could not match; he could do no wrong. Paintings that fit the team's notion of perfection are by Rembrandt; imperfect works are not. A concept frequently brought up in the argument is "Monday mornings": Did Rembrandt have them? As Bob Haak puts it, "It is a question of not just how well he could paint, but how badly."

A number of experts answer this question with: "More badly than the RRP believes." Many are sure that Rembrandt was capable of extremely varied work—that, indeed, his Monday mornings could occur anytime during the week. Christopher Brown says that Rembrandt made mistakes, did hurried and clumsy work, and left paintings unfinished. He was sometimes under great pressure to churn out commissioned work. Even Wilhelm von Bode noticed Rembrandt's failings, although he

wrote, defensively, that they were "merely incidental to his great and original genius. . . . The thinker and the poet in him were still greater than the painter; they even worked occasionally to the detriment of the artist, seducing him into a fantastic handling of simple motives that demanded a purely realistic treatment."[7] Haak himself some years ago conceded that there were less than perfect Rembrandts. About a dubious version of *The Sacrifice of Abraham* in Munich, he wrote in his 1969 book on Rembrandt that he believed it to be by Rembrandt despite weak passages in the composition, because such weaknesses occur in certain other large-scale works by the Master.[8]

When I mentioned to Ernst van de Wetering that some of the Project's critics thought its approach narrow and Calvinistic, and that the *Corpus* seemed to refuse to allow Rembrandt an ability to err, he demurred. I then asked him for an example of a Rembrandt Monday morning and, after a pause for thought, he proposed the *Bellona* in the Metropolitan, a painting that "just didn't work out." But in contrast to van de Wetering, who was taking an entire painting as a mistake or failure, the critics of the RRP are able to allow Rembrandt mistakes in paintings that are not necessarily failures, but may even be masterpieces.

In fact, as Arthur Wheelock has noted of one Rembrandt, "some clumsiness may make it authentic rather than not authentic." Quite often Rembrandt seems to have lost interest when it came to painting hands. Indeed, for Walter Liedtke, the weaknesses in the Beresteyn portraits—the clumsy hands and awkwardly foreshortened arms—are "characteristic."[9] David Bomford, a restorer at the National Gallery in London, regards the horse in the Frederick Rihel equestrian portrait as undoubtedly painted in Rembrandt's technique, with the paint layers built up in the same way as on the rest of the canvas; but for Bomford, Rembrandt was having an off-moment, or not trying very hard.[10] Peter Sutton declares, "Quality is not an argument for authenticity. A painter of such invention and originality as Rembrandt would not have painted lace in the same way each time." Rembrandt's lifelong interest in experimentation, which could result in variations and inconsistencies, and which is testified to by artists who have studied his painting technique, is to be seen also in his

drawings and etchings—bodies of Rembrandt's work that critics of the RRP believe the Project doesn't take sufficiently into account.

An effort to purify the oeuvre of Rembrandt drawings is being separately carried out by Peter Schatborn at the Rijksmuseum, but the difficulties of such a task are apparent when one considers the reattribution of a drawing of a child's head (in the Rembrandthuis), once considered to be of a small boy and by Rembrandt, to an "unknown pupil" whose subject was a young girl (ill. 17). Nigel Konstam, the English sculptor who is a student of Rembrandt drawings, has written to Bruyn and van de Wetering: "I find Rembrandt hugely more variable than your team will allow. I can give very many instances where the quality of the work on a single sheet, all clearly by Rembrandt himself, varies from exquisite to poor, by any standards. In spite of this fluctuating quality, I find my Rembrandt not only is a far more prolific artist but is more interesting and has far more to teach us, perhaps because he is more human (and, incidentally, closer to the artist revealed by the documents)."[11] It might be worth recalling Jonathan Richardson's warning, some two and a half centuries ago, against the "exalted characters" that influenced connoisseurs to believe a work could not be by the hand of a master whom they held in such esteem. Even the divine Raphael, Richardson wrote, "might be in haste, [or] negligent, or [might] forget himself. . . . Could the inferior master, to whom the work is to be attributed upon account of these faults, be supposed capable of doing the rest? . . . It is easier to descend than to mount. Raphael could more easily do like an inferior master, in certain instances, than such a one could do like Raphael in all the rest."[12]

Two other factors may lead the team to fail to accept authentic paintings as Rembrandts. One is condition. John Brealey thinks the Project is not allowing for the wear and tear that paintings suffer over the course of three hundred years and more. The paintings of Rembrandt in particular, always popular, have been cleaned more frequently than most old paintings; there is less of the original surface of the painting to be seen. A flattened, skinned, or much-restored picture may no longer look as if the Master painted it. The second factor is that no one can claim absolute certainty about how Rembrandt painted. For all the scientific analysis and

close study of brushstrokes, there is great difficulty in pinning down exactly how Rembrandt laid paint on canvas and panel. The mid-nineteenth-century German writer Eduard Koloff expressed the at the time not uncommon thought that Rembrandt's technique had aspects of sorcery about it, and that the painter himself had no idea how he achieved his effects.[13] Ernst van de Wetering once painted a portrait of Maryan Ainsworth, using materials similar to Rembrandt's, grinding his own pigments, and trying to emulate Rembrandt's style. Ainsworth (who has long curly brown hair and dazzling hazel eyes) was not impressed by the Rembrandtesque quality of the result. She says, "Handling and energy are elements that count for as much as materials and technique, and Rembrandt's handling and attack don't seem to be things one can copy."

Handling the News of Rejection

THE SENSE of loss felt when a Rembrandt is rejected can be immense. In the case of *The Polish Rider*, even the possibility of deattribution produces something of the effect of an impending death: part of our world, of what we know and care about, is on the point of being cut away. If such feelings are common among ordinary viewers, the sensations of the owners of a rejected picture are more acutely painful—and are certainly not alleviated by the immediate reduction in the monetary value of the picture, which is an unavoidable effect of the rejection.

The members of the RRP have come to realize that their method of approach may have caused even more deeply hurt feelings. Josua Bruyn has admitted that the RRP team failed to warn owners of the possible implications of deattribution. "Indeed, we did not say when we first got in touch that we wanted to know whether their Rembrandt was genuine or not. Rather, we said that we were compiling an oeuvre catalogue and wanted to study their Rembrandt for that purpose. This led to controversy some-

times, when the painting proved not to be authentic." Moreover, the news of rejection was conveyed to owners of paintings dealt with in volume one of the *Corpus* in a not very tactful manner. Some owners were upset that they received no advance notice that they were going to have to do without the tremendous satisfaction of owning a Rembrandt. One private collector is said to have learned from a newspaper that his Rembrandt was in the C category; he was, understandably, furious. An American collector refused to allow a reproduction of his *Rest on the Flight into Egypt* to be published in the first volume of the *Corpus* after hearing that it was going to be deattributed. He had bought the painting not long before from an English owner, in whose collection a pair of investigators from the RRP first studied it. (The new owner did eventually adjust to the situation and to the Project's attribution of the painting to Gerard Dou and Govert Flinck, and he allowed photographs of it to appear in an appendix to volume two.) The Duke of Westminster, one of the wealthiest men in Britain and the owner of the formerly unquestioned portraits of the painter Hendrick Martensz. Sorgh and his wife, heard from the RRP in its early days that the team thought the paintings were by Rembrandt; but with the publication of volume three he has found the members have changed their minds and he is—in terms of the estimated value of the portraits at auction—some £20 million out-of-pocket. Nevertheless, he has kept a stiff upper lip, declaring that scholars in the future may well reattribute them. (Christopher Brown continues to believe in them as works of the Master.) In the meantime, says the duke, Rembrandts or not, the quality of the paintings has not changed.[1]

The RRP now makes a point of letting the owner—and only the owner—know its verdict before a volume of the *Corpus* is published; a crafty proprietor could therefore sell a picture before it was publicly deattributed. But before the auction, in January 1988, of *A Bearded Man in an Archway*, Sotheby's asked the owner to allow the RRP to give its opinion in public—since the appropriate volume of the *Corpus* was still in the future. Bruyn's verdict, bravely published in the auction catalogue, was that the painting was "from Rembrandt's workshop but was not executed by the artist himself." Both Christopher Brown and Egbert

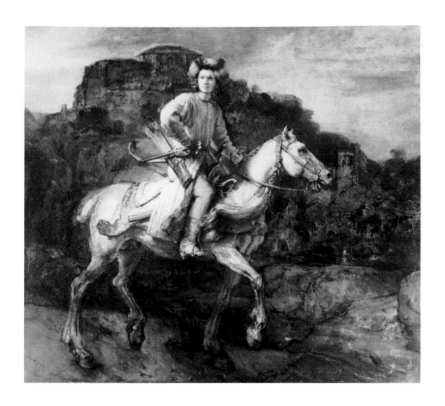

1. Rembrandt. *The Polish Rider*, c. 1655. Oil on canvas. (Copyright The Frick Collection, New York)

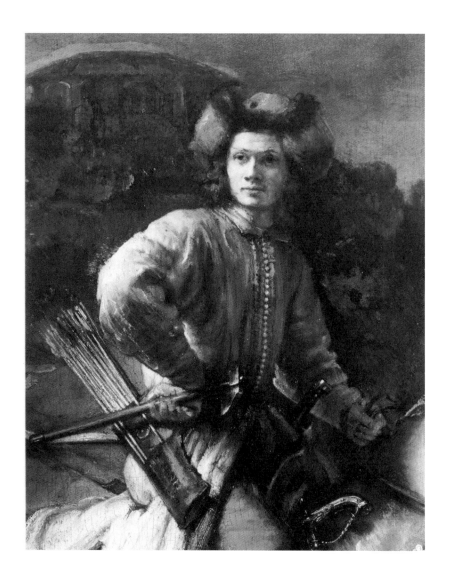

2. Rembrandt. Detail of *The Polish Rider*. (Copyright The Frick Collection, New York)

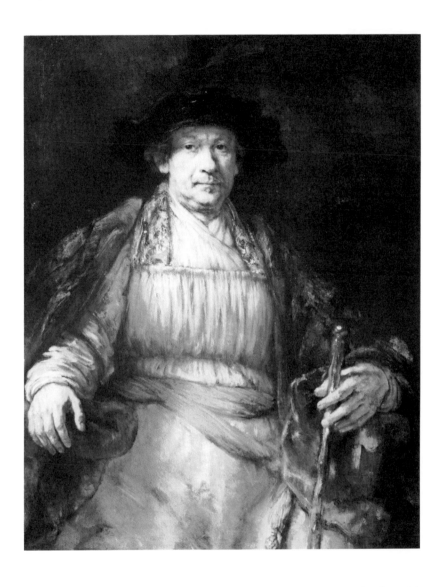

3. Rembrandt. *Self-Portrait*, 1658. Oil on canvas. (Copyright The Frick Collection, New York)

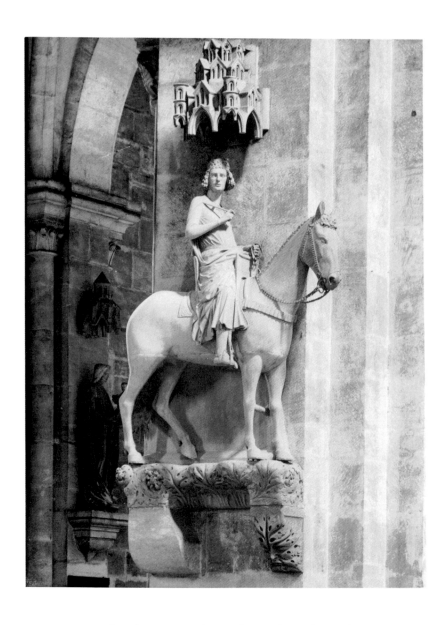

4. *Miles Christianus* ("The Bamberg Rider"), thirteenth century. Stone carving. (Bamberg Cathedral, Germany)

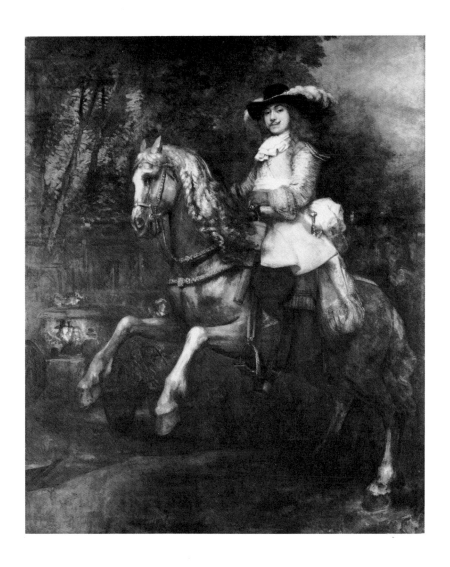

5. Rembrandt (and assistant?). *Portrait of Frederick Rihel on Horseback*, 1663(?). Oil on canvas. (Reproduced by courtesy of the Trustees, The National Gallery, London)

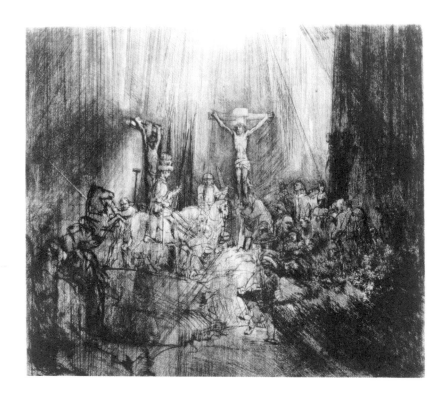

6. Rembrandt. *The Three Crosses* (fourth state), 1653 or later. Etching, drypoint, and burin. (The Metropolitan Museum of Art, New York, Gift of George C. Graves, 1920)

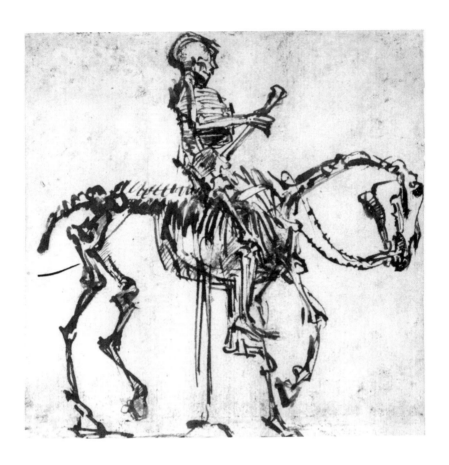

7. Rembrandt. *Skeletal Horse and Rider*. Pen and bister drawing. (Hessisches Landesmuseum, Darmstadt, Germany)

8. Stefano della Bella. *Polish Horseman*, 1650s. Etching. (The Metropolitan Museum of Art, New York, The Elisha Whittelsey Collection, 1967)

9. Stefano della Bella. *Polish Horsemen*, 1650s. Etching. (The Metropoli-
tan Museum of Art, New York, The Elisha Whittelsey Collection, 1967)

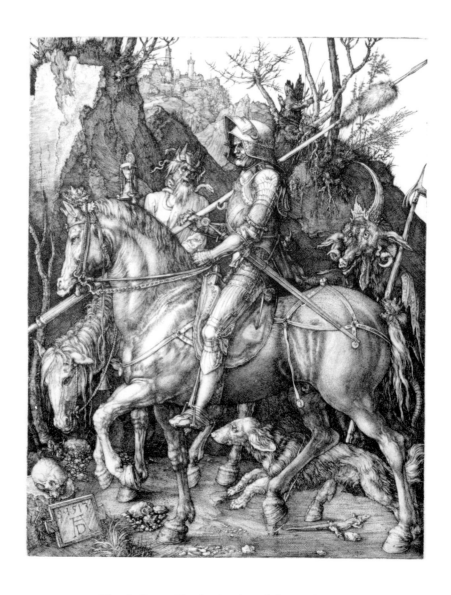

10. Albrecht Dürer. *Knight, Death, and the Devil*, 1513. Engraving. (The Metropolitan Museum of Art, New York, Harris Brisbane Dick Fund, 1943)

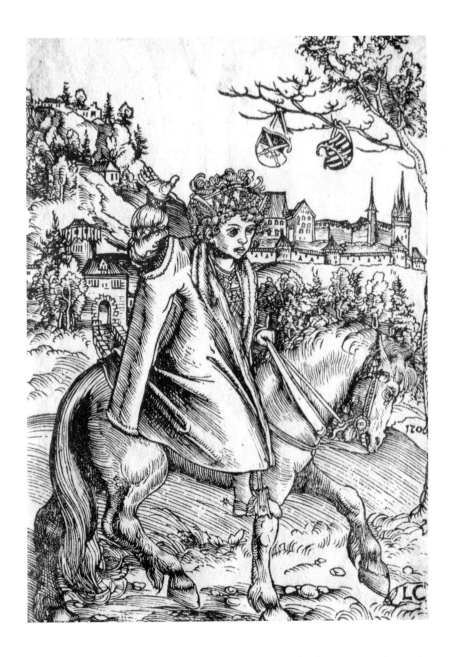

11. Lucas Cranach. *A Saxon Prince on Horseback*, 1506. Woodcut. (The
Metropolitan Museum of Art, New York, Rogers Fund, 1918)

12. Abraham de Bruyne. *Der Poolsche Reyter*, 1617. Engraving. (The Metropolitan Museum of Art, New York, The Elisha Whittelsey Collection, 1951)

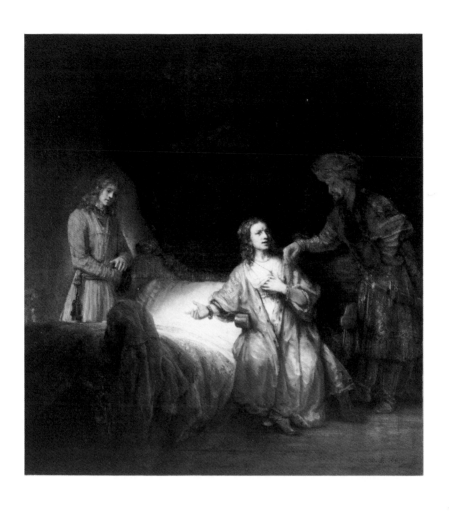

13. Rembrandt. *Joseph Accused by Potiphar's Wife*, 1655. Oil on canvas.
(National Gallery, Washington, D.C., Andrew W. Mellon Collection)

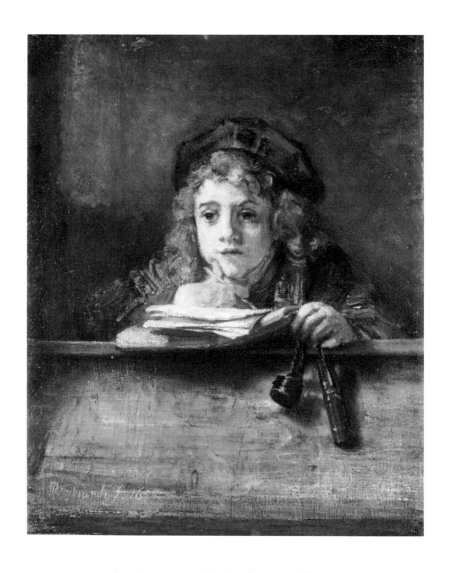

14. Rembrandt. *Titus at His Desk*, 1655. Oil on canvas. (Museum Boymans–van Beuningen, Rotterdam)

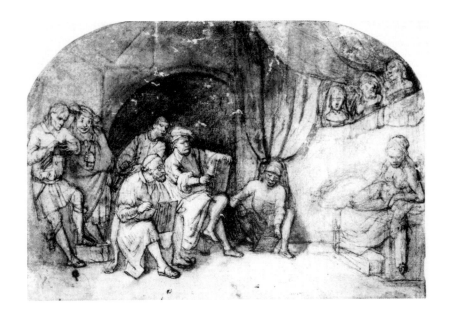

15. Pupil of Rembrandt. *Life Class Drawing a Female Nude*. Drawing. (Hessisches Landesmuseum, Darmstadt, Germany)

16. Rembrandt. *Portrait of a Man*, 1632. Oil on canvas. (The Metropolitan Museum of Art, New York, The H. O. Havemeyer Collection)

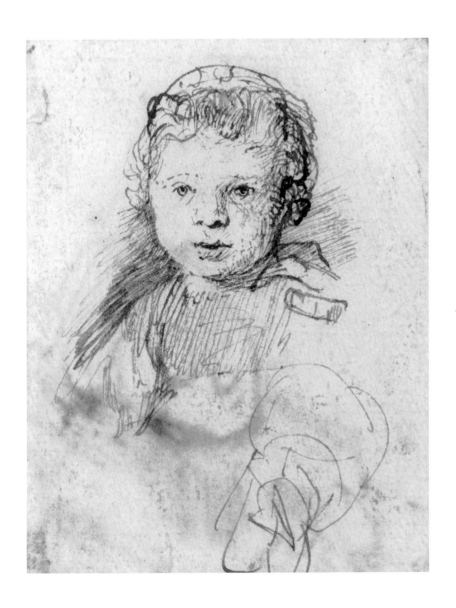

17. Rembrandt (or pupil?). *Drawing of a Child*. (Museum het Rembrandt-
huis, Amsterdam)

18. Willem Drost. *Bathsheba Reading David's Letter*, 1654. Oil on canvas. (Musée du Louvre, Paris)

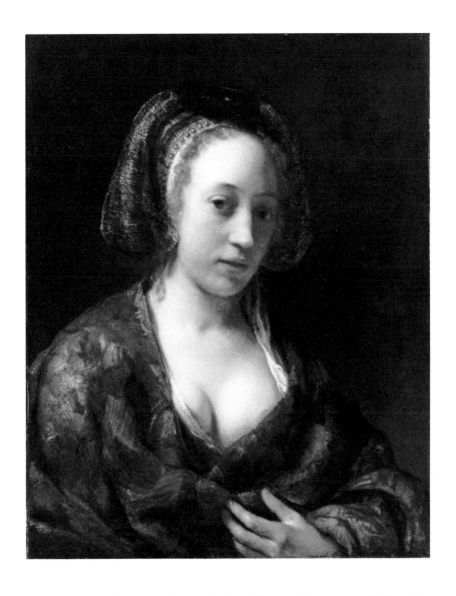

19. Willem Drost. *Portrait of a Young Woman*. Oil on canvas. (Wallace Collection, London)

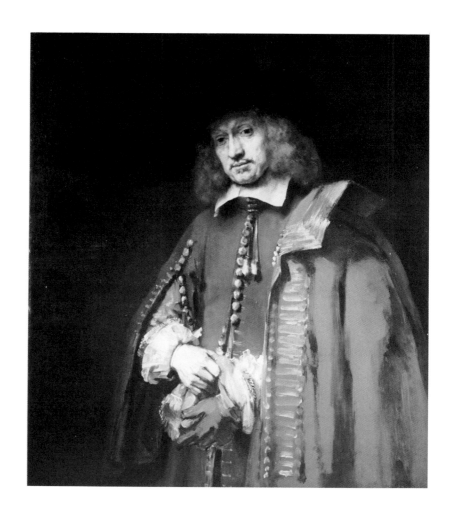

20. Rembrandt. *Portrait of Jan Six*, 1654. Oil on canvas. (Six Collection, Amsterdam)

21. Rembrandt. *Landscape with Rest on the Flight into Egypt*, 1647. Oil on panel. (National Gallery, Dublin)

22. Rembrandt. *Christ Returning from the Temple with His Parents*, 1654. Etching and drypoint. (The Metropolitan Museum of Art, New York, The H. O. Havemeyer Collection)

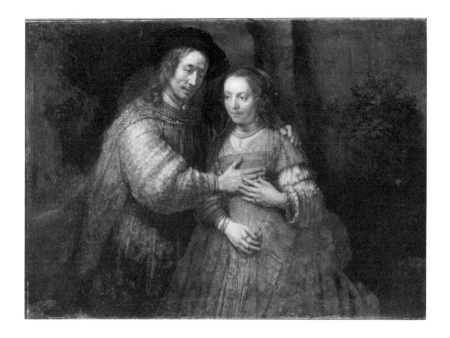

23. Rembrandt. *The Jewish Bride*, c. 1655. Oil on canvas. (Rijksmuseum, Amsterdam)

24. Rembrandt. *The Artist in His Studio*, c. 1629. Oil on panel. (Museum of Fine Arts, Boston, Zoe Oliver Sherman Collection)

Haverkamp-Begemann believe the painting is by the Master, and Arthur Wheelock says that "there are good reasons for thinking portions of it at least are by Rembrandt." The impact of the RRP judgment, however, was such that the painting was sold for $800,000 instead of the $10 million it might have gone for as an undisputed Rembrandt. In other words, the value of the picture was reduced by more than ninety percent.

A collector who had the money, liked gambling, and saw things in the long term might think it worthwhile to buy a disputed Rembrandt or two. An art lover might look on the bright side of the situation. J. W. Smit, a Dutch professor of history at Columbia, recently remarked, "The Rembrandt Research Project may make it possible for me to buy *The Polish Rider*!"

For museums and large state and public collections, the demotion of their prized possessions might be thought to involve less emotional reactions. But David Freedberg thinks that curators can respond as private collectors do, and may even feel greater terror at the prospect of deattribution by the Project. Rumors circulate through the museum world about where the members of the team may strike next. Freedberg says, "I hear, for example, that the *Lucretia* in the National Gallery in Washington is now doubted by them." So far, the RRP has rejected Rembrandts in the Louvre, the Hermitage, the Metropolitan, Windsor Castle, the Mauritshuis, the national galleries in Washington, London, Ottawa, and Stockholm, and important museums in such cities as Berlin, Boston, and Kassel. The Norton Simon Museum in Pasadena, California, has had its 1637 *Self-Portrait* deattributed, a fine painting for which, at Christie's in 1969, Norton Simon paid the then world-record price for a Rembrandt of 460,000 guineas ($1,159,200); the museum has staunchly refused to change the label or endorse the methods of the RRP. And apparently it refuses to allow the publication of a photograph of the painting in the *Corpus*, where the team assigned the work to Carel Fabritius—an attribution which Leonard Slatkes, among others, finds "almost beyond belief."[2]

Some museums are better able than others to handle rejections. The Dutch art historian Albert Blankert has noted that at the Wadsworth Atheneum, in Hartford, Connecticut, the "attractive" *Portrait of a Young*

Man was moved from a place of honor to the basement on losing its Rembrandt attribution.[3] At the Wallace Collection, in London, where paintings bought by three generations of the Hertford family are shown, twelve were considered a hundred years ago to be by Rembrandt, although several of them, by any standards, looked dubious. By the time Bredius came to prepare his catalogue in 1935, four of these had been weeded out. Gerson deattributed three more. Now four of the remaining five have been "lost" through the RRP, which this time ensured that the Wallace Collection was kept informed of the team's thinking. The collection director, John Ingamells, putting the best face on adversity, actually thanked the team for its work, and was in turn presented by the apparently surprised and grateful members with a complimentary copy of volume three of the *Corpus*. More recently Ingamells has put all twelve paintings and several related works on show together as an example of changing perceptions of Rembrandt and awareness of his pupils. The exhibition certainly demonstrated the brilliance and ostensible authenticity of the one unquestioned picture, a portrait of Titus wearing a red beret, but left some experts unconvinced about the RRP's verdict on several of the others, including one from the 1630s, *Landscape with a Coach*, which the team considers to be probably by Govert Flinck, and a large dramatic history painting, *The Unmerciful Servant*, for which Willem Drost is suggested as author. The Berlin Gemäldegalerie, having independently decided against *The Man with the Golden Helmet*, also chose not to act shy and embarrassed; it made the painting the centerpiece of an exhibition with accompanying X rays, blowups of paint samples, and photographs of works by Rembrandt pupils.

Gary Schwartz has observed that "experts or insiders have their own way of dealing with the problems of deattribution, like stockbrokers who tell you with a straight face that the market discounted six months ago figures which you just heard on the radio."[4] Arthur Wheelock, evidently not terrorized, believes that large museums can generally stand their ground—they have their own scholars, their own research programs. His institution, the National Gallery in Washington, already is reassessing its Rembrandts in the course of conservation work and makes use of RRP

findings without feeling threatened by them. In 1991, it put its *Lucretia* on show alongside another *Lucretia*—from the Minneapolis Institute of Art. Both paintings seem to reflect Rembrandt's interest in theater: a play by Pieter Cornelis Hooft about the Roman maiden, who was raped by the son of a Roman tyrant and stabbed herself to death, was staged in Amsterdam in the 1660s when these pictures were painted. At the National Gallery in London, with roughly a score of Rembrandts, the RRP's deattribution of the *Man in a Room* had been preceded by the gallery's own doubts about the painting; the team's rejection of *Anna and the Blind Tobit*, which it attributed to Gerard Dou, even met with the agreement of Christopher Brown, the gallery's deputy keeper. But he thereafter looked at the painting when it was hung alongside two undisputed and much sharper works by Dou at the "Master and His Workshop" exhibition, and he now believes that the RRP is wrong and that the painting probably should be reattributed to Rembrandt. It is known to have had engravings made after it, as a Rembrandt, not long after it was painted.

In some instances, the controversy over a reassessment may be so great, and argument so widespread, that there is less pressure on a museum to accept a new attribution. Even if it should be accepted, such a change would probably not be made manifest very quickly in most museums, which do not usually have a staff member detailed to run around altering labels. The Metropolitan in New York has in fact deattributed several of its Rembrandts, mostly on the basis of autoradiographic evidence, yet the labels on the frames or the walls still read "Rembrandt." Thus it is with the labels next to the Beresteyn portraits. Although in 1986 the museum gave the impression it was in retreat before the RRP deattribution, it soon rallied its forces. The paintings were shown and discussed at a comparative exhibition and symposium in Boston in early 1987, attended by the RRP team, and Walter Liedtke, the Metropolitan's curator of Dutch and Flemish paintings, began the proceedings with a strong defense of the paintings as Rembrandts. At the end of the symposium, the participants divided more or less neatly—the Dutch against the Rembrandt authorship of the Beresteyns, the Americans and British for it. As far as the museum is concerned—and after all, it has its autoradiographs

as convincing evidence—the Beresteyns are still Rembrandts. Meanwhile, the RRP has had further proof of the dissent its verdict on certain paintings can arouse, and has concluded that in some cases advance work needs to be done before publication of the rest of the *Corpus*. Josua Bruyn says, "It seems best to us nowadays to try to prepare museum directors and members of the art-loving public for what may be a shock."

The Case of **The Polish Rider**

WHAT ARGUMENTS do the Project's members use when they are asked to put their case against Rembrandt's authorship of *The Polish Rider*? What reasons do those who disagree with the Project in this matter give? And what do the waverers have to say?

Bob Haak, of the RRP, says, "All over, the painting is a little too weak. It is not at all balanced. I don't see Rembrandt's brushstrokes. There's the expression of the face, the impossible leg, the very strange horse. And then the whole background—well, it could be unfinished, but some tiny details in it led us to conclude that it was finished or nearly so, and in that case the painting is not by Rembrandt." Josua Bruyn says, "Pictorially, *The Polish Rider* seems to me to spring from a temperament different from that of the 1658 *Self-Portrait*. The modeling of the figure, the feeling of the landscape—it is all much softer. A more feminine temperament is at work." Ernst van de Wetering says, "In Rembrandt, things always have a certain weight, a certain 'body-ness' or stability. Here, with *The Polish Rider*,

everything is too slim. The entire painting is shaky. The proportions of the figure are strange. There is a lack of relationship between the figure and the background—and I am convinced Rembrandt always got his backgrounds right first of all. There is a great deal of detail that isn't incorporated in the whole scene. And the lighting is curious—it breaks up the unity of the painting. All this makes me doubt the picture, makes me wonder if another mentality was behind it."

That mentality and "more feminine temperament" were given a name in Bruyn's review of a book by Werner Sumowski that appeared in *Oud Holland* in 1984—a review the RRP chairman may have intended also to prepare the Frick Collection for a shock about *The Polish Rider*. In conversation, Bruyn recognizes the painting as one of those fabulous pictures which attract devotion: "It is a case," he says, "where we have to tread carefully." However, if the remarks in *Oud Holland* were an instance of this, then the sound of eggshells crunching under Bruyn's feet reverberated around the art world. Bruyn himself has not committed his colleagues; his "own personal doubts have been expressed." The expression took the somewhat roundabout form of proposing in the book review that when examining the possible work of Rembrandt pupils, and in particular that of Willem Drost, "to clear the terrain, one will not have to forget a number of paintings which until now are considered Rembrandts—*The Seated Man with a Cane* in London (National Gallery), or the so-called '*Polish Rider*' in the Frick Collection, which at the least shows remarkable similarities with Drost's early, Rembrandtesque work."[1] I doubt that it does Bruyn an injustice to suspect he must have felt relief, perhaps even wry pleasure, at finally getting this off his chest. Since 1969, he had been living with his own conviction that *The Polish Rider* was not by Rembrandt, and in more recent years with a belief that Drost was probably its painter. According to Gary Schwartz, rumors that *The Polish Rider* was going to be on the Project's hit list had circulated in Dutch art historical circles nearly fifteen years before that issue of *Oud Holland*. Apart from his possible wish to prepare people for a shock, Bruyn may well have felt a strong need to satisfy those clamoring for a public statement—and perhaps all the more so because the relevant volume of the *Corpus* was, and is, still in the future.

Whatever the case, any element of caution in Bruyn's expression of doubt was ignored by a number of commentators. Sylvia Hochfield wrote of Rembrandt's being "stripped of some beloved works, such as . . . *The Polish Rider*."[2] Svetlana Alpers's book seems to regard the deattribution of the painting as a fait accompli and beneath an illustration of it gives the artist as Rembrandt—but with the name in quotation marks to denote the now RRP-authorized doubt.[3] A question mark is actually attached to the "Rembrandt" in the caption for the reproduction of the painting in the catalogue of the 1991–1992 Berlin/Amsterdam/London show.[4] In a 1986 article titled "The Faker's Art," Joseph Alsop suggested that for the RRP the authenticity of *The Polish Rider* was of no consequence.[5] This led Bruyn to protest that "the Rembrandt Research Project . . . has not 'sat in judgment' on *The Polish Rider* [as Alsop had written] nor 'decided to remove it from the sacred list of authentic Rembrandts' . . . leave alone 'by a vote of three to two'!" No member of the Project thought of the painting as a fake, Bruyn concluded, "and there should have been no place for it in an article on 'the Faker's Art.'" To the then director of the Frick, Everett Fahy, Bruyn wrote that "there was some misinformed talk—not to say gossip—about our team's opinion on *The Polish Rider*," and he enclosed a copy of his letter of protest, which, he hoped, made the Project's position clear.[6]

The matter of fakery may not be at issue here—although Alsop might not have been as misinformed as Bruyn claimed when Alsop placed the RRP and *The Polish Rider* in that context. Svetlana Alpers has pointed out that in volume one of the *Corpus*, a member of the team complained, in regard to some rejected paintings: "In a number of cases it is all but impossible to decide whether the Rembrandtesque aspect is due to a deliberate, or even fraudulent, intention or to Rembrandt's direct influence on a pupil or follower."[7] In the early years of the Project, the team apparently assumed that part of the problem was the existence of a large number of eighteenth-century fakes or pastiches among the "accretions" to the Master's oeuvre; but very few of these have in fact been found by the team. One that might fall into that category is the seemingly eighteenth-century Rembrandtesque *Man in a Room*, formerly known as *Scholar in a Lofty Room*, in the National Gallery in London. For that matter, the art of fak-

ing presumably came into being not long after the art of creating; art experts continue to be taken in by works of all periods; and *Fingerspitzengefühl*, the ability to discern a fake immediately, is as rare among connoisseurs as the ability to admit, "I don't really know who painted it." And while it is true, as Bruyn protests, that the RRP has not yet formally reached a verdict on *The Polish Rider*, Alsop's perception of how the team might vote does not appear wildly inaccurate. Of the three crucial members who might make up a majority for the rejection of the painting, Bruyn told me that in his opinion *The Polish Rider* was definitely a C painting; Bob Haak agreed, saying it was not by the Master; and Ernst van de Wetering, while a little more hesitant about committing himself to anything that sounded like a final judgment, was happy to talk about the many features of the picture that would move one to reject it.

At the Frick, Bruyn's ranging shot in *Oud Holland* and the correspondence about the Alsop article have been the only items received concerning the Project's intentions toward *The Polish Rider*. The gallery has made no public announcements on the subject. Despite a healthy $15 million endowment from its founder, which enables the collection to continue to buy works of art (more than a third of its paintings have been bought since Henry Clay Frick's death), the Frick does not have the resources of a large museum. It has no expert on Dutch art or scientific investigator on its staff. It brings in conservators from outside; and since its governing regulations prohibit paintings from being taken out of the building, trips to Brookhaven for neutron bombardment and autoradiography are ruled out. The Frick's small scale and somewhat sequestered character seem to nurture less of-the-moment qualities. It has no big, blockbuster shows; no restaurant; no roving children under ten; and no groups streaming through its rooms in pursuit of lecturers dispensing cultural tidbits. The adjacent library is a scholarly haven, which until 1990 insisted that male readers wear jackets and female readers skirts.[8]

Yet despite the outward calm and customary serenity of the Frick, one soon learns that several of its senior officers are infuriated by the Rembrandt Research Project. The current director is Charles Ryskamp, who came from the Pierpont Morgan Library in 1987. A specialist in eighteenth-century art and literature, he has a stout, pink-gray

eighteenth-century look about him. (Sir Joshua Reynolds would be the artist for *his* portrait.) Ryskamp is not shy about the Frick. He says, proudly, "If there were a poll on the subject, I'm sure the Frick would be chosen as the world's favorite museum. Have you read Peter Sutton's book *Dutch Art in America*? He writes, 'Painting for painting, the Frick Collection is quite simply the greatest in the world.'" Of these paintings, there are two or three that continue to provoke most public reaction— *The Polish Rider* is one. Before I came here, I heard of Professor Bruyn's theory and I thought, So what? Now, I still couldn't care less what the Rembrandt Research Project says. Connoisseurship has an ugly name these days, and a good deal of the labor of art historians does nothing to increase our joy. I don't think the Project's opinions detract from one of the greatest paintings on earth. It is unthinkable that it isn't by Rembrandt. To prove that it is not by him, someone is going to have to assemble a body of work for an artist capable of that kind of masterpiece. To me, the problem of Rembrandt is similar to that presented by Shakespeare. Some people just can't accept his genius. They want to chip away at the hugeness of it. They come up with other authors for the plays—noblemen preferred, of course. Shakespeare's father was a smallholder. Rembrandt's father was a miller. I think the Project is a Dutch attempt to make Rembrandt tidy, safe, and rational. It is an attempt that is concerned with only a few qualities of the paintings, and does not take in other qualities, which create responses in the hearts of people all over the world who look at the pictures. Anyway, even if the Dutchmen say that *The Polish Rider* is by Jan Smit, it is not going to come out of that room. Surely the severest test is how it stands up in there, surrounded by fine pictures, and with the 1658 *Self-Portrait* for company."

Despite the director's passionate dismissal of the Project, the Frick in late 1987 invited Ernst van de Wetering to give a talk about *The Polish Rider* and the Project—to show, perhaps, that the gallery could handle this sort of problem with confident and unruffled courtesy, and perhaps, as well, to give the enemy a chance to expose its positions. Van de Wetering accepted. He titled his talk "Rediscovering Rembrandt," and he spoke without a prepared text. Egbert Haverkamp-Begemann, who was in the audience in the Frick's small auditorium, said of the talk, "I thought

it was a courageous act, like that of Daniel going into the lions' den." Edgar Munhall, the Frick's curator, commented that van de Wetering spoke "most of the time about the problems of Rembrandt attribution in general, and only a little about *The Polish Rider*. It was a most unconvincing performance."

Van de Wetering was careful to explain to his audience that he had *not* said, "The painting is not by Rembrandt." He has since emphasized that there is "nothing firm yet" about the RRP's decision on *The Polish Rider*, and has added that Bruyn's comments in *Oud Holland* have been exaggerated. "In any event," he says, "these early, premature opinions aren't worth very much." Yet he is aware that these opinions and the team's doubts have had far-flung effects. They have undermined the confidence with which some scholars—even those who continue to have other disagreements with the RRP—view *The Polish Rider*. Haverkamp-Begemann says, "I see weaknesses now that I didn't see before. I'm afraid *The Polish Rider* will probably sink." Although Gary Schwartz had been resisting the reattribution, he has admitted that doubts brought on by the RRP forced him to look at the painting more critically: "One then discovers that features of the painting which were always considered marks of its greatness as long as it was a Rembrandt—a certain vagueness, a poetic suggestiveness, an ambiguity of meaning—turn into signs of inferior artistry when they are attributed to Drost."[10] David Freedberg admits, "I've looked at it more closely because of the RRP. I suppose I'm now inclined against its being by Rembrandt. Yet it is a great picture. It continues to move me more than any other Rembrandt in New York except the *Self-Portrait* on the same wall. The team will have to be pretty skillful to prove it's by a certain pupil."

"If it is by a pupil, then it is his masterpiece," is an observation often made by dissenting experts about some of the more contentious RRP deattributions, and about *The Polish Rider*. John Brealey is one of many who considers this a great painting, "one of the masterpieces of painting in America. If it is not by Rembrandt then we are in the ridiculous position of launching a quest for a missing and hitherto unrecognized Titan."

For Josua Bruyn, the quest may be over, the pupil found, in the shape
of Willem Drost; he is, apart from Aert de Gelder (who was Alfred von
Wurzbach's nomination), the only pupil or follower so far put forward by
name for authorship of the painting. In coming up with a specific name,
Bruyn heeds the admonition the Project offers in the *Corpus*, that is, "tak-
ing seriously the principle . . . that no painting should be rejected unless a
new attribution is possible."[11] And he gives credit to two men for helping
create this possibility: Ernst van de Wetering, whose study of Rem-
brandt's workshop forms chapter 3 of the second volume of the *Corpus*,
and Werner Sumowski, the first volume of whose heavily illustrated cat-
alogue of the Rembrandt school occasioned Bruyn's *Oud Holland* re-
view. Bruyn believes that Sumowski has "come up with a fairly convinc-
ing personality for Drost," on the basis of eight paintings (seven of which
are signed "W. Drost") that apparently constitute the bulk of Drost's
known oeuvre[12] (ill. 18, 19). It might be noted that John Van Dyke in
1923 called Drost "one of the most accomplished and original of the
Rembrandt pupils, with much sensitiveness and feeling. Taken as a
whole, his pictures present us with a new personality in art."[13] Van Dyke
credited to Drost the *Portrait of a Man* in the Duke of Westminster's col-
lection, which is signed "Rembrandt 1647." He was less sure about the
companion portrait of a woman. In the eight Drost works favored by Su-
mowski, Bruyn—following Sumowski—sees Drost as an artist whose
pictures often contain soft, rounded masses of drapery and figures iso-
lated by a strong sidelight that gives the impression of attaching itself to
the surfaces. He used strong brushstrokes and favored yellow and white,
brown and red.[14] Bruyn's theory is given partial support by van de Weter-
ing, who picks his words carefully: "Some of the properties I see in *The
Polish Rider* I see in Drost's work." Yet Bruyn himself now and then seems
to acknowledge that he may be too far out on a limb. He told me, "This is
a suggestion—not a fixed opinion. Before being absolutely sure, we have
to go into Rembrandt's own work for the 1650s and also carefully exam-
ine Drost's work, including his etchings and drawings." (There are several
signed etchings by Drost but no signed drawings.) Bruyn, as it happens, is
one of the few experts who do not consider *The Polish Rider* a master-

piece. Although he calls it a great picture, he says that if it is by Drost it is not a masterpiece, because Drost composed it in a style that was less than original, being derived partly from Rembrandt.

It might help if we knew about Willem Drost. In fact, little is known; neither the date of his birth nor the date of his death is recorded. The first record of his name as yet found in Holland is in Houbraken, where one Drost is mentioned as a pupil of Rembrandt and as an artist who spent considerable time in Rome.[15] A signed self-portrait etching of 1652 appears to be the first work known of his. A document recently uncovered in Florence describes a painting in the Uffizi, dating from about 1655, as a self-portrait by Drost.[16] The painting previously has been attributed to other artists, and it certainly shows the influence of another Rembrandt pupil, Carel Fabritius. But there seem to be no other biographical references to Drost, and the lack of evidence may, indeed, contribute to an unfairness, in failing to assign to Drost pictures that belong to him. Undoubtedly, unsigned works of art can gravitate (or be pushed by dealers) toward powerful identities; minor artists may lose out. But that said, there is, to my mind, little in Drost's small currently known body of work that would lead one to believe he could paint unaided a picture that reverberates with such mysteries and complications as *The Polish Rider*. His work shows Rembrandt's influence and displays a similar interest in biblical figures, but in a much more straightforward way. The subjects are simply presented. They are what they say they are, and that's all. In his *Ruth and Naomi* in the Ashmolean Museum, Oxford, depicting the Old Testament scene in which Ruth tells her mother-in-law that she will return with her to the land of Judah, there seems no real relation between the two figures; their faces are inexpressive. To this viewer, moreover, Drost's paintings favor the smooth, fine style that a fashion for the classical began to encourage in the Netherlands in the second half of the seventeenth century (and which commanded higher prices), over the rougher, less finished late manner of the Master. In their scholarly survey *Dutch Art and Architecture, 1600–1800*, Jakob Rosenberg, Seymour Slive, and E. H. ter Kuile write of the light velvety quality and regular diagonal hatched strokes characteristic of Drost's work.[17] The view of probably most critics of the RRP on this matter is expressed by Arthur Wheelock:

"The Drost we know hadn't the creative power to paint *The Polish Rider*." Walter Liedtke writes of Drost as one of the "lesser associates of the Master" who have become "convenient receptacles of marginal pictures that even Valentiner came to reject."[18] Werner Sumowski, it should be noted, does not mention *The Polish Rider* in relation to Willem Drost.[19]

The "shakiness" discerned in *The Polish Rider* by the Rembrandt Research Project is seen also by viewers who do not believe the painting was done by anyone other than Rembrandt. In 1910, Walter Sickert, while calling the work "one of the perfect masterpieces of the world," wrote that the face of the rider was lacking in "plastic observation." To Sickert it was "a spiritual rather than a plastic portrait of a face."[20] And there were other flaws: "No Rembrandt is quite Rembrandt without, somewhere, an unexpected bit of drawing that is a little stumpy, and squarer than one expects. . . . I see this trait in the knee of *The Polish Rider*—just enough to be, not a flaw, but an added emphasis on the signature."

One area of alleged weakness in *The Polish Rider* that the Project fastens on is the background. Some members of the team regard it as not Rembrandtlike because of its unfinished appearance; associated with this criticism is a perception of a break or disjunction between the background and the horse and rider in the foreground. But these features may not add up to much of an argument against Rembrandt's authorship. As we have seen, George Stout, when he was working on the picture for the Frick in 1938, concluded that the background had been damaged and restored. Furthermore, although Rembrandt, like almost all seventeenth-century Dutch artists, generally worked from back to front, painting the background first, he did not always do so, and he did not always finish his backgrounds.[21] Maryan Ainsworth points to a portrait of Hendrickje Stoffels in which Rembrandt's attention was on the sitter's face rather than other parts of the picture. "Perhaps he abandoned the rest," Ainsworth writes, adding that "the question of paintings left unfinished by Rembrandt has not been thoroughly studied."[22] Ernst van de Wetering acknowledges that Rembrandt did not finish the hands in his self-portrait now at Kenwood House in London, although perhaps because of diffi-

culties arising from his looking in a mirror and shifting his palette from the hand that usually held it to the hand he painted with.[23] For Christopher Brown, the Project's notion of a break between background and foreground is exasperating: "I've heard them say it about other pictures which are clearly by Rembrandt, and I think it's silly." He also believes that the effect may be due to the simple fact that Rembrandt failed to finish the painting. Brown, too, has a close-at-hand example of Rembrandt's readiness to leave a painting unfinished; it is another presumably uncommissioned work, the London National Gallery *Portrait of Hendrickje Stoffels* of 1659. One more work of that period, the 1654 *Portrait of Jan Six*, is painted in broad brushstrokes, and a large element of it, Six's red cloak, hanging from one shoulder and dominating the right side of the picture, is remarkably sketchy; still, its unfinished quality does not seem to have worried the subject, who commissioned it, and in whose family house in Amsterdam it hangs today (ill. 20).

Whether finished or unfinished, Rembrandt's later paintings struck some of his more finicky contemporaries as badly finished, with the paint splashed on and the impasto—according to Baldinucci—half a finger thick. Houbraken said that Rembrandt worked so quickly in later life that his paintings, examined closely, looked as if they had had paint smeared on with a bricklayer's trowel.[24] John Elsum, an English writer of verse epigrams about painting, attended enthusiastically to Rembrandt in 1700:

> What a coarse rugged way of Painting's here,
> Stroaks upon Stroaks, Dabbs upon Dabbs appear.
> The Work you'd think was huddled up in haste,
> But mark how truly ev'ry Colour's plac'd . . .
> Rembrant! Thy pencil plays a subtil Part.
> This Roughness is contriv'd to hide thy Art.[25]

As for Jonathan Richardson, he thought a loose, free painting was harder to imitate than a painting that was highly finished.[26]

For several other connoisseurs, the background of *The Polish Rider* furnishes no cause for doubt as to who painted it. Egbert Haverkamp-Begemann says that there is nothing about the background to make one

question the picture and that it is indeed in Rembrandt's manner. For Julius Held, the background is, in fact, proof rather than disproof: it is part of "Rembrandt's own artistic property," prefigured in the 1647 *Landscape with Rest on the Flight into Egypt* (National Gallery, Dublin), "where the small figures nestle in the protection of the dark landscape behind them" (ill. 21). And Held sees in other Rembrandt works a similar relation of foreground to background, of central figure or figures to the hills behind, and a similar movement along the same slight diagonal[27] (ill. 22).

No art historian has devoted as much time to *The Polish Rider* as has Julius Held. His long article about the painting, which originally appeared in 1944,[28] was his first major work and his means of introducing himself to the American art world. He initially saw the painting in 1934, when, at age twenty-nine, he arrived in New York from Germany and went almost immediately to the Frick. As a young art historian specializing in Flemish and Dutch painting, he had been an assistant in the state museums in Berlin. In April 1933, like many other Jews in Germany, he lost his job. He was fortunate to be taken up by an American financier, Clarence Palitz, who wanted advice on assembling an art collection and who sponsored his voyage to the United States. From 1937 to 1970, Held taught at Barnard and Columbia, his six annual courses always including one on Rembrandt, and frequently incorporating visits with his students to the Frick to study *The Polish Rider* and, in later years, to the Metropolitan to look at *Aristotle Contemplating the Bust of Homer*. At Barnard, he became professor of art history and chairman of the art history department. Many of his former students are now teaching in their turn or working in museums. Among Held's principal written works are a two-volume catalogue of the oil sketches of Rubens and a collection of essays, *Rembrandt Studies*, which includes the article on *The Polish Rider*.

Since 1971, Held has been living in semi-retirement in Bennington, Vermont, giving occasional lectures, writing, and examining paintings for dealers and collectors. (Among the latter was J. Paul Getty, who wanted to buy a painting believed to be by Rubens and so brought Held to his Sutton Place estate in England to give his opinion. Held told Getty it

was a Rubens with student help. This didn't satisfy Getty, who wanted to know exactly what percentage was by Rubens. Held said there was no answer to that, unless one were able to count the brushstrokes done by Rubens and those done by apprentices.) Now in his late eighties, Held spends most mornings in the large library of his home, which is just down the road from the handsome 1805 clapboard church in whose graveyard Robert Frost is buried. When I visited Held, he had just returned from a visit to his birthplace, the small town of Mosbach, near Heidelberg, where he had been invited to participate in a ceremony honoring those who had suffered on Kristallnacht. We talked for a moment about the horrors of that time, before turning, as to a refuge, to Rembrandt and the RRP.

A fine distraction! Held grimaced at the mention of the team. "You mean the Amsterdam Mafia," he said. He had studied the *Corpus*—too expensive for him to purchase—in the library of the Clark Art Institute in nearby Williamstown, and it had bolstered his suspicions about group connoisseurship. "In our field, it's hard to get two people to agree totally. As for five—impossible. To achieve a consensus in print, much disagreement must be hidden. Then there is always bound to be a mixture of the objective and the subjective, which the Project plays down. And perhaps most worrying of all, I find in the *Corpus* a peculiar insensitivity to the works themselves. The members of the team look at the details—a leg, a foot, a lace collar. But they don't get the overall feeling."

Held was fully prepared to acknowledge that many paintings traditionally attributed to Rembrandt are not by the Master. "Gerson did a good job of cutting down an inflated oeuvre. But the process has to stop at a certain reasonable point. Of course, there will always be marginal cases where disagreement is possible. However, *The Polish Rider* is not one of those cases." His own involvement with the painting remains intense, and he has kept up with scholarly writing about it. Reviewing some of this, he said that he found unconvincing the suggestion that the work has a connection with the Socinians. "They were pacifists—one of them wouldn't be shown bearing arms." As for the Prodigal Son theory, where's the bag for the young man's money? Held agreed that the rider probably

does wear Polish costume, and that there is quite possibly a link with one of the Ogińskis who were in the Netherlands in the mid–seventeenth century. But unlike Ben Broos, who has proposed this, Held does not believe the picture is a straightforward portrait. "I feel it is an idealized portrait, perhaps commissioned by the younger Ogiński brother, Marcyan, who was nineteen in 1650, the year he matriculated at Leiden University—a portrait done in terms of a youthful Polish national hero who fought against the Eastern intruders, like Marc Sobieski, or such leaders in battle against the Tatars and Turks as Prince John Radziwill of Lithuania and the famed Albanian Giorgio Castriota, known as Scanderbeg." Held believes it would have been possible for young Marcyan Ogiński to have himself portrayed in that guise, just as Dutch burghers and their wives had themselves limned as, say, Antony and Cleopatra.

Held admitted to me that he was not an expert at distinguishing the hands of various Rembrandt pupils, but with the first volume of Sumowski's catalogue *Gemälde der Rembrandt-Schüler* open before him, he examined the illustrations of the Drosts. "Pleasant pictures, smoothly modeled, all very decent—he gets the chiaroscuro—but pedestrian in comparison with Rembrandt. No, it cannot be." Held turned to a six-by-seven-inch print of *The Polish Rider* and a postcard detail of the rider's head and shoulders which I had put on the table, and said, his voice rising with urgency, "Look! Look at the face of that young man! The free modeling, the freedom of the brush, everything so boldly handled! When you turn to Drost, or any of the pupils, you look in vain for this level of work. And what about the horse? No self-respecting Dutchman would have a horse that looked like this. This is a useful old horse that clearly grew out of Rembrandt's drawing of the skeletal horse and rider—you can see the bones there. And see how horse and rider move from left to right, and how the rider's head seems to be on the point of coming out from the looming presence of the hill to the lightness of the sky—it hasn't yet, but is just about to, and the viewer feels that, anticipates it. Then note the little watch-fire with people around it, painted with know-how, evoking a sleepy mood in the background, and reminding one of other works by Rembrandt. And as for the finished or unfinished quality of the back-

ground—well, to me it is the way Rembrandt often painted his back-grounds. It is broad. But he is not a *Kleinmeister*, involved in niggling things. And although I see a break between foreground and back-ground—perhaps the lack of cohesion the Project talks about—it has a purpose. It causes the rider and horse to stand out in the light of dawn against the nocturnal setting. Are those people blind!"

A Matter of Emotion

For the members of the Rembrandt Research Project, I suspect, Julius Held's feeling about *The Polish Rider* would disqualify him as a reliable advocate. His ardor is great—and he admits it: "I know. I stick my head out." He does not believe in an aseptic, emotionless art history of the sort that Josua Bruyn, for one, apparently seeks to practice. Bruyn is applauded for his effort by some younger Dutch art historians, among them his former student Rob Ruurs, but this deliberately dispassionate approach may fail to take into account that when a human being stands in front of a picture, certain things happen that are not entirely rational. Gary Schwartz recognizes this and confesses to having undergone, as a student, in the presence of Rembrandt's work "moments of something like mystic transport."[1] And he has said that one thing that led him to write about Rembrandt was a desire "to find a way to deal with this emotion that came out of me in front of the work."[2] David Freedberg, I recall,

in the course of a rational enough conversation about the Rembrandt Research Project, said of *The Polish Rider*: "It continues to move me."

This effect of a work of art on the emotions is surely an important factor in our attempts to name the author of such a work, even if the effect is hard for many art historians to deal with. Although most people who stop to think about it will admit that certain colors affect different people in different ways, and that artists combine colors and shapes in paintings to express subject, mood, and form, the idea that "art effects some kind of emotional contagion"[3] (to quote E. H. Gombrich, one sympathetic to the notion) is often labeled romantic—which seems an unnecessary delimitation. Before the Romantic age, Jonathan Richardson observed that "to consider a picture aright is to read; but in respect of the beauty with which the eye is all the while entertained, whether of colours or figures, it is not only to read a book, and that finely printed and well bound, but as if a concert of music were heard at the same time: You have at once an intellectual and a sensual pleasure."[4]

It is a general truth of human nature that we enjoy having our emotions stirred; that we are gratified when art moves us, whether through our reading, hearing, or seeing; and that, as Goethe put it in *Faust*, "if you don't feel it, with all the pains in the world, you won't get hold of it."[5] Richard Wollheim writes: "Art rests on the fact that deep feelings pattern themselves in a coherent way all over our lives and behaviour."[6] Wollheim has drawn attention to Walter Pater's interest in the sensations art arouses in us. In an essay about Botticelli, Pater asks: "What is the peculiar sensation, what is the peculiar quality of pleasure, which his work has the property of exciting in us, and which we cannot get elsewhere?"[7] To understand *The Birth of Venus*, says Pater (as paraphrased by Wollheim), "we must understand the sentiment with which Botticelli infused it." And Wollheim goes on: "To get at the work of art as it really is, to describe its surface in such a way as to display the match between surface and depth, to apprehend the formation of 'pictorial qualities,' Pater relies most heavily upon the technique of association: the placing of the work firmly in the web of association where it belongs. The associations that Pater collects to the object are varied in origin: associations from cultural history, from mythology, from the biography of the artist, or just associations of

feeling and sentiment."[8] Max Friedländer may have muddied rather than clarified the matter by trying to distinguish between Emotion and Feeling, calling "the stirring and irritation of the soul emotion and the stirring of the senses feeling."[9] Painters themselves of course know how intimately connected emotion is with art—it was put once and for all in the famous declaration by John Constable (also a miller's son): "Painting is with me but another word for feeling."[10]

After Pater, an art historian who confronted this matter with admirable style was Bernard Berenson. He was not fond of Rembrandt; his wife, Mary, reported after a visit she made with him to the Rijksmuseum in 1911: "We were greatly perturbed by Rembrandt, a painter we both abhor."[11] But Berenson seems to speak as a feeling man and thinking art scholar when he writes:

> Art deals with the emotions, and do what we will to pump ourselves dry of prejudices and accidental feelings, do what we will to be cautious and judicious, our final impression of works of art remains an equation between them and our own temperament. Every appreciation is, therefore, a confession, and its value depends entirely upon its sincerity.[12]

Even so dry and ponderous a scholar as Heinrich Wölfflin finds himself forced to use the word "feeling" when it comes to Baroque art—"a new domain of feeling has opened"—and in particular when he discusses Rembrandt, "with his feeling for the living quality of light which, withdrawing from every substantial form, moves mysteriously in infinite spaces."[13] It appears a defining characteristic of Rembrandt's works—as important as the brushstrokes, the underdrawing, the types of ground, and the pigments he used—that they *move* people exceedingly. Roger Fry, trying to put his finger on the way in which the viewer is brought to share Rembrandt's mood, talked of pigment taking the impress of spirit.[14] Many of Rembrandt's works affect our feelings more profoundly than do those of lesser artists; they make us open ourselves to being moved by them, and they help us feel something of what the artist may have felt about youth, old age, friendship, isolation, and love.

Outside the scholarly confines of the *Corpus*, at least one member of the RRP has been seen responding to a Rembrandt painting in this perfectly normal way. In his 1987 talk at the Frick, Ernst van de Wetering

projected a slide of the so-called *Danaë* in the Hermitage and termed it "one of the miracles of the world, one of the most beautiful paintings. How the light touches and caresses the body!" I acknowledge similar reactions to a painting that actually shows a caress, the painting in the Rijksmuseum called *The Jewish Bride*: the man with his hand laid lightly on his companion's bosom, her fingers gently touching his (ill. 23). The rendering of cloth and skin, the colors of gold, yellow, brown, and vermilion are very much like those of *The Polish Rider*. It would seem that if two different artists painted these pictures, one could emulate not only the style and technique of the other but also the power to inspire emotions. And it is the recognition of this emotional impact of Rembrandt—this spell his paintings create—that may be a necessary element in the complex business of attribution. A subjective element, perhaps, but—to borrow Josua Bruyn's term—one could claim it fairly to be "intersubjective" among millions who are moved by Rembrandt.

One should, however, take note of a possible problem. It is a difficult question to answer but it should be asked: Are some of these feelings aroused not so much by the painting as by the thought that it is by Rembrandt—which may result from the fact that we have been told it is by Rembrandt? Egbert Haverkamp-Begemann suggests that when we look at a work of art attributed to Rembrandt, we are inclined to see Rembrandt characteristics. Ernst van de Wetering writes in the *Corpus*: "It is disturbing to realize that the amount of artistic pleasure the viewer derives from one and the same painting seems liable to considerable variation, depending on one's ideas about the authenticity of the work in question."[15] Gary Schwartz also has no doubts about this: "Once a painting is degraded from the status of a genuine Rembrandt, the visual, aesthetic and spiritual qualities observed in it until then cease to exist." And about *The Polish Rider*, he comments that the features "always considered marks of its greatness as long as it was a Rembrandt—a certain vagueness, a poetic suggestiveness, an ambiguity of meaning—turn into signs of inferior artistry when they are attributed to Drost."[16] I think Schwartz overstates the effect of "degradation," but doubt can and does affect our perceptions; we should certainly try to imagine what, if the name Rembrandt were removed from *The Polish Rider*, we would see and feel.

The Artist's Image and the Artist's Time

ANOTHER PROBLEM with similar complications arises from our conception of the personality we call Rembrandt, and attends us on each occasion we look at a picture we believe to be by him. This personality is formed in great part by experiences of pictures. But what if some of those pictures are not by him? And do we seek out pictures and call them Rembrandts because they fit our prior image of who the painter is? Ernst van de Wetering talks of the task of building up Rembrandt's artistic personality in terms of an ice floe which other floes, that is, paintings, may be attracted to or may slip past. Distinguishing between these, and giving them a push one way or the other, is an arduous business—and not without a chance of surprise. A painting may suddenly turn up, as did the early *Baptism of the Eunuch*, discovered in Utrecht in 1976. Van de Wetering says, "Our image of Rembrandt at the time would not have been able to generate the possibility of that picture." And yet the RRP decided it was an authentic work; the main ice floe was added to, and the personality of the

Master was slightly altered. For the RRP, the artist who begins to emerge from this long process is one with a piercing imagination, immense concentration, and a consciousness of being extraordinary, even regal. Van de Wetering finds this concentration and sense of specialness in Rembrandt's work from the beginning, for example in *The Artist in His Studio* in Boston. This rather gawky, even primitive little picture shows the young painter staring out from the background, while the foreground is dominated by an easel, seen largely from the rear (ill. 24). On the easel stands a panel whose nearest edge is indicated by a long, bright gleam of paint. "An intense, hard gleam," van de Wetering calls it; and it seems an emblem of the Rembrandt personality he and the rest of the team have in mind.

Whether the RRP will persuade most other Rembrandt scholars and devotees to share this rigorous view of the Master remains to be seen. As Egbert Haverkamp-Begemann points out, there is an inevitable time lag as the gestalt or shape of the artist in our mind is adjusted to suit the announcements of attribution and deattribution. For many, however, their image of Rembrandt—founded on numerous apparently unquestioned paintings, etchings, and drawings—is less hard-edged and single-minded than that of the team, and may resist attempts to alter it. *The Burlington Magazine* has editorialized that the authors of the *Corpus* sometimes make decisions about attribution that "do not necessarily accord with the way an artist in fact behaves.... That an artist, especially in his early years, may not have followed a completely logical path is in Rembrandt's case not entirely a matter of speculation, since we possess a number of signed and dated etchings, which display considerable diversity in style and purpose, and suggest that a similar variation may have been present in his painting."[1] Gary Schwartz has remarked in regard to four paintings of around 1655 that Rembrandt was clearly a painter "in control of alternative styles."[2] For Christopher Brown, difference and variation are just as important in Rembrandt's work as consistency, whether in his use of paint—where "colour and transparency are adjusted as continuously varied combinations of relatively few pigments"[3]—or in the different ways in which he painted details such as eyes and ears. Schwartz believes that "some of the vast differences between the iconographical and even

stylistic approaches in [some of Rembrandt's] paintings are unquestionably due to the character and interests of those for whom they were made."[4] In other words, variations made to order. Maryan Ainsworth also belongs to the less rigorous camp. The Project, she says, is "putting Rembrandt in a straitjacket. It allows him no breathing room."

Letting Rembrandt "breathe" may also involve recognizing something else that is not at all hard or concentrated, yet is to be found in many undisputed works. In that early *Artist in His Studio*, for instance, there is a curious distance, even a gap, between the diminutive figure of the painter and the huge, looming easel. The British art historian Nicholas Penny has noted "an imprecise narrative dimension" in some of Rembrandt's portraiture, such as the double portrait of a shipbuilder and his wife in the British royal collection (Queen's Gallery, Buckingham Palace), in which the wife is depicted rushing into the room, in her hand a piece of paper with a name on it that is neither hers nor her husband's.[5] What's going on? It is a question that a number of Rembrandt paintings make us ask—among them the *Danaë* in the Hermitage, which has been known under nearly a dozen different titles and whose subject is still argued about, and the self-portrait with Saskia sitting on Rembrandt's lap (in the Gemäldegalerie in Dresden), where the artist seems to be having a wild time while his wife is in a different mood, on another plane altogether. Sometimes Rembrandt was pedantically keen on historical accuracy, sometimes quite uncaring. He was also capable of starting a picture on one subject and converting it in midstream to something else: as X rays have shown, a *Judith and Holofernes* became *Saskia as Flora* (in the National Gallery, London); "a woman who had just chopped off a head was turned into a shepherdess bearing flowers."[6] Even self-portraits have been interpreted as not straightforward, not just what Rembrandt saw in a mirror. Gary Schwartz perceives them as part of Rembrandt's business, as "calling cards" that would remind patrons of his existence.[7] For J. A. Emmens, among others, the self-portraits can be viewed not only as evidence of Rembrandt's preoccupation with identity and his own inner life, but as assertions of the dignity of the artist's profession.[8] For many of us, of course, they also are among the most moving autobiographical statements in the history of art.

There is, then, often a "doubleness," even an "otherness," to be seen in
Rembrandt. In the Frick, it is emphatically demonstrated on that wall on
which the 1658 *Self-Portrait* and *The Polish Rider* hang together with the
two portraits by Frans Hals—both fine paintings of individuals but lack-
ing that extra, other dimension. It is an effect of Rembrandt's work that
some connoisseurs and art historians have tried to respond to. Horst Ger-
son wrote of "the strangeness of Rembrandt's art."⁹ Heinrich Wölfflin
used the term "inexplicable."¹⁰ To Eugène Fromentin, it seemed that
Rembrandt "was looking elsewhere."¹¹ For Walter Liedtke, Rembrandt is
"the most imaginative and willful artist active in seventeenth-century
Amsterdam," and Liedtke has pointed out that one inescapable point of
the *Corpus* is to be found for the most part between the lines: "This ex-
ceedingly complicated subject ultimately owes its origin to an intensely
complex man."¹² As for *The Polish Rider*, which Kenneth Clark called
"the most personal and mysterious of his later paintings,"¹³ Arthur Whee-
lock thinks that "its very strength comes from the tension between the
many elements in it and the many traditions it draws on." Its drama and
movement are Rembrandt qualities; its weaknesses are Rembrandt's,
too. And although the subject of the picture and the purpose of the rider
remain uncertain, that very uncertainty—who is he? where is he going?—
made marvelously manifest in paint, is a strong argument for those who
think that the Rembrandt Research Project is marching in the wrong di-
rection.

Josua Bruyn has said that before coming to its final decision on *The Polish
Rider*, the RRP will have to "look closely at Rembrandt's work in the
1650s." As noted before, there seems no dissent on 1655 as the date
for the painting, although this conjecture has hitherto been based on
the understanding that the picture was by Rembrandt and represented his
way of working at that time. In the years around 1655, Rembrandt pro-
duced such paintings as *The Slaughtered Ox*, *Bathsheba at Her Toilet*,
Titus at His Desk, *Joseph Accused by Potiphar's Wife*, the *Portrait of Jan
Six*, the *Woman Bathing*, *The Anatomy Lesson of Dr. Deyman*, and *Ja-
cob Blessing the Sons of Joseph*, one or two of which might be called
highly original, half a dozen of which are indisputably great. What may

have been the Master's last straight landscape, a river scene with ruins and a hill behind them, also dates from this time. In the mid-1650s—perhaps his most prolific period since his first years in Amsterdam—he also painted a large number of "half-lengths," pictures of saints, apostles, classical heroes, bearded men, old women, old men. He made many wonderful drawings, including the *Woman Sleeping* and the self-portrait *Artist in Studio Attire*.[14]

And what about those years themselves, and his life in them? Some art historians fight shy of history and even biography; it is as if the purity of their views of the artist's work would be contaminated by historical and biographical data. But if one assumes that Rembrandt was subject to the pressures, hopes, and anxieties that most people have at any time (staying alive, keeping a roof over one's head, feeding self and family), it seems likely that the general drift of and particular happenings within those years would have affected him. And although it is hard to say exactly which event had which effect, and to what degree, and how it was given expression, an extensive grasp of what went on in the 1650s, of the atmosphere of time and place, is essential for any expert intending to decide what works the artist did or did not do.

Josua Bruyn has not said anything about looking closely at Rembrandt's life in that decade. The first two volumes of the *Corpus* appeared to shun the artist who actually painted the pictures that had been examined in such detail. A doctrine current among some scholars concerns the dangers of the biographical fallacy, that is, the belief that one can find the artist in his or her works—a process that, in a vicious circle, could lead one to attribute works to the artist whose personality one has thus conjured up. This antibiographical attitude is perhaps in part a reaction to the excesses of past writers who—as Ernst van de Wetering has remarked[15]—saw the morals of the man reflected in his paintings, and therefore, because of such pictures as that of him carousing with Saskia in his lap, took him to be a boozy spendthrift. Some contemporary experts, Alpers and Schwartz among them, see a man within the limits of an artist whose work they regard as done almost wholly in reaction to his patrons and "the market." According to the *Corpus*, Rembrandt supplied paintings after 1656 generally in order to pay off debts.[16] Artists, like writers or

composers, may indeed produce for a market, for interested purchasers, but their work usually arises out of their own compulsions, interests, strengths, and apprehensions. And so Rembrandt's close and loving drawings of women and children, his marvelously observant biblical etchings, are not simply hackwork but were impelled by his nature, by the man he was.

In 1654, a two-year-old Anglo-Dutch war came to an end. An economic recession was felt throughout the decade. In 1653 trade was nearly at a standstill, fifteen hundred houses stood empty in Amsterdam, and the city fathers decided not to build the second story of the new town hall. In 1655, evidently feeling more buoyant, they went on with the building. Amsterdam continued to be one of the most welcoming, tolerant, and wealth-creating cities in Europe, but one in which the Calvinist ascendancy periodically made itself felt. Hellfire and damnation were part of the atmosphere. For Rembrandt's household, ecclesiastical trouble showed itself when the local church council admonished his common-law wife, Hendrickje Stoffels, for living "like a whore" with the artist.[17] (Hendrickje gave birth to Rembrandt's child Cornelia in the latter half of 1654.) And there were constant reminders of mortality. The plague hit Amsterdam in 1656 and caused the death of nearly 18,000 people. Rembrandt's most talented pupil, Carel Fabritius, was killed in an explosion of the Delft arsenal in 1654, and Frans Banning Cocq, who led out the guard in *The Night Watch*, died in 1655. The artist's financial problems, which seem to have resulted from his expensive house and expensive art-buying habits (and possibly from unwise or unlucky investments), intensified at this time: some of his possessions were auctioned off at the Keizerskroon Inn in 1655; he was declared insolvent in the following year; more of his possessions were then sold; and finally, in 1660, his large Breestraat house was sold.[18]

From this distance, it is a bumpy, unsettled time, with great highs and profound lows, and the constant, contradictory possibilities of enlightenment and doom. The Dutch historian Johan Huizinga has examined the conflict between the two prevailing cultures, Erasmian and Calvinist,[19] which seems similar to the tension in England between Cavaliers and Roundheads—or even within one individual, such as Sir Thomas

Browne, in whose works classical images are used to enforce Christian morals.[20] More recently, the historian Simon Schama has given in his book *The Embarrassment of Riches* a detailed picture of how an essential liberalism often appeared in what could be taken for a dogmatic age— and how, too, no rules of thumb apply when one tries to convey a complete portrait of the period: "There were more mysteries of the flesh and the spirit at work in Rembrandt's Holland than are allowed for by sociological cliché."[21]

A few other facts about the Master at that time: Rembrandt still had a number of talented pupils. He frequented various prominent people: He visited Jan Six on his country estate at Ijmond and drew him there, writing. He was in contact with such eminent physicians as Arnold Tholinx, inspector of the Amsterdam medical colleges, whose portrait he both etched and painted in 1656, and Tholinx's successor in that post, Dr. Johannes Deyman, whose anatomy lesson he depicted in the same year. He had professional dealings with a print seller, a goldsmith, an art dealer, a writing master, and a Portuguese Jewish merchant, and with the bailiff of the Court of Insolvency, "Old Haaring," whose portrait he etched. He seems to have been able to turn adversity into copy. The inventory of his belongings made for the court in July 1656 lists among his own works various landscapes—by twilight, with mountains, unfinished—and a painting referred to simply as "a horse, from life."[22] One wonders . . . (No painting of a horse by itself survives.)

During the 1650s a number of Dutch artists were pressing for recognition as artists, not just craftsmen. In 1655, forty-eight artists applied for exemption from membership in the Guild of St. Luke, where they found themselves lumped together with woodcarvers, embroiderers, and common painters.[23] It is possible that despite his money troubles, Rembrandt, churning out considerable work, was feeling artistically potent; one can imagine a picture of a youthful rider on his game old horse as a free-lance artist's symbol of rekindled hope.

As for Willem Drost, where was he at this time? If what Houbraken had to say is credited, and one takes into account the self-portrait by Drost in the Uffizi, dated circa 1655, and the document concerning it in the Florentine archives, it appears likely that he was in Italy. *The Polish Rider* is

not known ever to have been in Italy. It is a fairly large picture, not the sort of work most painters would have produced without a specific commission, just for their own interest. And if Drost, wherever he was, is judged by his signed Rembrandtesque paintings of this period, they are closer to Rembrandt's style of the 1640s than to that of the 1650s.

Unanswered Questions

"T"HE REMBRANDT Research Project is just a stage in the history of connoisseurship," says Arthur Wheelock, calmly taking the long view. Wheelock points out that the Rembrandts deattributed several decades ago by Horst Gerson, to anguished reactions, are not necessarily gone for good: the *Saul and David* in the Mauritshuis and the 1650 *Self-Portrait* in the National Gallery in Washington have their defenders, and volume one of the RRP *Corpus* reinstates the self-portrait in Oriental costume with a poodle, now at the Petit Palais in Paris, all rejected by Gerson. Other scholars don't feel quite so relaxed. Michael Kitson says, "There is no doubt that someone else will do a corpus in the future, but I don't think it will be for another fifty years." David Freedberg believes that although not all of the RRP's negative judgments may stand, its impact will be lasting, and there will be great difficulty in again expanding Rembrandt's oeuvre. Josua Bruyn is confident that the chance of reacceptance of paintings rejected by the RRP is very, very slight.[1] And Gary Schwartz has

somewhat masochistically remarked that once a painting is dropped as a Rembrandt, it is in "a category in which it finds itself in the company of some of the ugliest Dutch paintings of the seventeenth century."

But the RRP itself is subject to change, and it is scarcely halfway through its self-appointed task. Two of the original members have gone. It is beginning to sound a bit defensive. Ernst van de Wetering confesses that "the force of the reaction from the world to our work frightens us." Josua Bruyn admits, "We all get older, and human memory and human perseverance are limited." Bob Haak agrees that "it has all gone on too long." Both Bruyn and Haak are aware of the problem involved in seeing a picture in, say, 1970 and writing it up in 1992. Haak is uneasy about his memory of paintings seen so long ago, some of which may not be revisited easily. Bruyn believes that the Project's method of study and the language it uses in its notes will enable any new members to make judgments of the sort he would approve of, but he thinks new members should also see paintings for themselves; views, therefore, may change. Some close observers of the Project feel that with the publication of volume three of the *Corpus*, and the running down of Josua Bruyn's great stamina, a shift has been taking place. The baton in what seems to be both relay and marathon is being handed over to Ernst van de Wetering.

Although van de Wetering holds Bruyn's old professorship, he is a man of different temperament. Someone who has studied under both men considers "Bruyn more rational, van de Wetering more intuitive." Van de Wetering had academic training as a painter before studying art history; when he grapples with the difficult business of expressing in words how a painter paints, it is with sympathy for the painter's problems. He is a jovial man, not only aware of the attachment many people feel for Rembrandt but giving the impression that he doesn't hold it against them. He is committed to the methodology of the Project—starting from doubt, looking long and hard at the painting as an object; but as he told me, he stands also for "having more shades between certainty and uncertainty. Of course, the Project is trying for as much certainty as possible—that's in the tradition of all connoisseurs who make an oeuvre catalogue. Yet we need to express the fact that sometimes a firm decision can't be reached. In future, we may have to expose in public the interaction between the ar-

guments for and against the authenticity of a painting." When I put to him my doubts about the deattribution of a *Descent from the Cross* (C49 in the *Corpus*) he responded: "As far as I'm concerned, the discussion can stay open." In his talk at the Frick in 1987, he touched on the difficulty of dividing the properties in *The Polish Rider* between Rembrandt and a follower or pupil: "Where do you cut the umbilical cord between pupil and master? The final answer may never be given."

Yet if the verdicts of the RRP under van de Wetering are going to be less black-and-white than they have been under Bruyn, with fewer C's and many more B's, this may have to do with something other than van de Wetering's personality. The Project may no longer need to blaze a trail: it has shaken up the world of Rembrandt studies; it has overcome a good deal of inertia and a good many received ideas; it has conveyed some of its doubts to a new generation of museum curators. Moreover, the Project's membership may change to take account of criticism the *Corpus* has received for slighting documents and writings concerning Rembrandt. The RRP has asked Ben Broos, an expert in the literature, to be a consultant on historical matters; he may, however, not want to be involved in questions of authentication and, some feel, may not find it easy to accept the command structure of the team. Discussions have also been held with a scientific investigator, Mrs. C. M. Groen, who has assisted with the *Corpus* and may assume a more permanent role. Still, van de Wetering seems to be taking the lead in these matters. It is also his private view (about which Bruyn, he says, "gets upset") that the composition of the team should be looser—should reach out to such experts as Haverkamp-Begemann and Wheelock, who are at once critical and understanding. "One of my dreams is to have several meetings a year with people like them to discuss as much as we can before the *Corpus* volumes are published. Debate, even when heated, sharpens our arguments, makes us less ingrown, and contributes wonderfully to our sense of fellowship."

Whether van de Wetering's expansiveness will be altogether reflected in the ensuing volumes of the *Corpus* remains to be seen; no dissenting opinions were printed in the third volume. Some suggest that he has a way of sounding more moderate than he in fact is. Little catholicity is to be found in the 1991–1992 exhibition "Rembrandt: The Master and His

Workshop," where the paintings and drawings were divided into the firmly accepted and the firmly rejected, where there were no B's. When asked at the time of the exhibition for his thoughts on *The Polish Rider*, van de Wetering replied somewhat peevishly, *"The Polish Rider* is a painting we should not talk about now. I'm not ready for a discussion about it."[2]

Time continues to be a problem, as van de Wetering is one of only four professors in his university's art history faculty, and has had all of art from 1400 to 1800 to teach. Teaching *or* the Project seems to be the choice he is faced with. Shortage of money may also be a difficulty. The Project has gone on far longer than the sponsor, the Netherlands Organization for the Advancement of Pure Research, envisaged. Bruyn says that for the Project to survive, "more paid help is needed." Van de Wetering admits that the team has had "a bit of a battle" with its patrons for funds to carry it through the next decade, and in the last year or so has on occasion sounded furious with critics of the RRP who may—he seems to suggest—make so much noise they imperil that funding. Gary Schwartz, who has an ear close to the ground of Dutch art history and publishing, believes the Project will not be able to finish the *Corpus* in the manner in which it was started. "They'll have to reduce the amount of information printed, particularly for paintings the *Corpus* deattributes." For Bob Haak, this would be a pity: "We've tried to shorten our descriptions of each painting, of paint layers, et cetera, but the results are less truthful to our experience—less convincing, and less accurate about what we observed." It will be interesting to see what effects these changes and constraints have on the Project, and particularly whether the authority and decisiveness needed for a *Corpus* can be combined with elements that critics of the Project have found lacking—elements that Arthur Wheelock may have in mind when he says, "Modesty and humility are necessary when dealing with great art which has resonances for so many."

Every time I am in New York, I visit the Frick. I walk slowly through it, looking at the Vermeers, the Turners, the Bellinis, the Goyas, the Whistlers, the Halses, and the Rembrandts—a college of paintings, one enhancing the next. It is so right a place that there is no need to look at every-

thing; one can revisit old friends, one can gaze at other paintings anew. I sit for a while on a marble seat in the covered courtyard and listen to the plash of the fountain. Voices are hushed, the guards, in their cranberry-red uniforms, uninsistently present. Waxy green plants grow beneath stone columns. It is a temple to art, a place that encourages reverence and reveries. Certainly Mr. Frick's hospitality, which can be purchased for three dollars, leads one to bless the memory of the man who in life was a brutal strikebreaker and a pioneer inside-trader.

I wander to the long northwest gallery and pause to pay my respects to the 1658 *Self-Portrait*, taking note of that look—at once majestic and full of self-doubt—which the painter addresses to himself, and therefore to the viewer, before I move along to *The Polish Rider*. The young man's self-absorption is similar to that of the artist, as if his thoughts were momentarily distracted from the purpose of his journey. I remember an earlier visit, when two elderly ladies came past the painting while I stood there, and one exclaimed to the other, "Youth! Youth!" I let my mind leap back to the time, more than seventy years ago, when old Mr. Frick, not long before his death, received René Gimpel, an art dealer. Gimpel was led by servants to this gallery, where he found Frick. As he records in his memoirs, he thought that since he had last seen the magnate, Frick had "grown stouter and entered a more advanced state of elderliness: His face is crumpling, his pink complexion becoming patchy; his fair beard, which used to be a thick mass, is growing finer. But his cold eyes, grasping and hard under their genial look, remain a clear, beautiful blue."[3] After making that connoisseurlike appraisal of his host, and while attempting to sell Frick a Watteau for $130,000, Gimpel looked around the room. "The finest picture is the Rembrandt self-portrait.... Another magnificent Rembrandt is The Polish Cavalier.... If his face were not that of a young man, I would swear it is the Wandering Jew who goes there, in that landscape in which all uncertainties are summed up, in which home and hearth move farther away at each step, where the air is one immense doubt."[4]

Postscript

T
HE FOLLOWING letter appeared in *The Burlington Magazine*, April 1993:

> Madam, Since its foundation in 1968, the Amsterdam-based Rembrandt Research Project has become known internationally for its work and publications. The original team consisted of six members, later reduced to five following the deaths of J. A. Emmens in 1971 and J. G. van Gelder in 1980 and the appointment of E. van de Wetering in 1970. These changes were not announced at the time, since they had no effect on the aim and methodology of the programme. The Rembrandt Research Project would now like to inform colleagues and other interested parties of far more sweeping changes that have taken place.
>
> The long duration of the project, which is directly related to the ambitious objective, the dynamic working method, which is subject to constant review, and the limited time that the team members have been able to devote to Rembrandt research alongside their full-time appointments at universities or museums, have all taken their toll. A critical point was reached

in 1989 with the publication of the third of the planned five volumes of *A Corpus of Rembrandt Paintings,* which closed with the *Nightwatch* of 1642. The passage of time made itself felt not only in changes in the personal circumstances of the team members, all of whom had retired from their posts or were on the point of doing so (the sole exception being Van de Wetering, who had succeeded to Joos Bruyn's chair at the University of Amsterdam), but also in the conviction of Ernst van de Wetering—the team member who had the longest future with the project—that there was a need for a change of approach. His argument that the overrigorous classification of the paintings into categories A (accepted as being by Rembrandt), B (uncertain) and C (not accepted as Rembrandt) should be abandoned, and that there should be room for consultation with a broader range of specialists (including the curators of those paintings in public collections) before publication of the research findings, received a sympathetic hearing from the other team members but failed to generate the enthusiasm necessary for a concerted change of course.

Aware of the need to adapt to altered circumstances, and secure in the knowledge that their younger colleague has a clear idea of the way ahead, J. Bruyn, B. Haak, S. H. Levie and P. J. J. van Thiel have decided to bring their participation in the project to an end. It will continue under Ernst van de Wetering, assisted by a small staff, and with the collaboration of specialists from various disciplines.

<div style="text-align: right">

J. Bruyn, B. Haak, S. H. Levie
and P. J. J. van Thiel

</div>

Notes

FOREWORD (PP. XIII–XIV)

1. When asked why the 1991–1992 exhibition "Rembrandt: The Master and His Workshop" presented a number of unquestioned works and a number of works now firmly reattributed to pupils, but no works about whose authors there were doubts, Pieter van Thiel, director of paintings at the Rijksmuseum and one of the exhibition organizers, told a reporter, "It would only be disturbing if we confronted the public with these problems" (*The Guardian* [London], July 26, 1991).

A YOUNG MAN ON HORSEBACK (PP. 1–5)

1. J. Bruyn, review of W. Sumowski, *Gemälde der Rembrandt-Schüler*, vol. 1, *Oud Holland*, 98 (1984).
2. A. Wheelock, conversation with the author. Hereafter I will not repeat such a source for quotations in the text, unless there is ambiguity. If no reference is given for quotations (generally accompanied by, for example, "Wheelock says" or "Bruyn said"), the reader should assume that the remarks were made in the course of a conversation with the author.
3. J. S. Held, "Rembrandt's 'Polish Rider,'" *The Art Bulletin*, 26 (1944);

repr. and rev. in *Rembrandt's Aristotle and Other Rembrandt Studies* (1969); repr. with a postscript in *Rembrandt Studies* (1991). The last publication was used for citations herein.

4. Ibid.

5. Frick Collection Curatorial File and B. Davidson and E. Munhall, *Paintings of the Frick Collection: An Illustrated Catalogue*, vol. 1, pp. 258–265. Bredius later reported his reaction: "Just one look at it, a few seconds' study of the technique, were enough to convince me instantly that here, in this remote fastness, one of Rembrandt's greatest masterpieces had been hanging for nigh on a century" ("Onbekende Rembrandts in Polen, Galicie en Rusland," *Nederlandsche Spectator*, 25 [1897], pp. 197–199, cited by J. Boomgard and R. W. Scheller, "A Delicate Balance: A Brief Survey of Rembrandt Criticism," in C. Brown et al., *Rembrandt: The Master and His Workshop*, p. 117).

6. V. Woolf, *Roger Fry, Painter and Critic*, p. 150. Although Fry used the term "Poland"—perhaps in a traditional or prescient way—Dzików at this time was within the Austro-Hungarian Empire, albeit a Polish-speaking part of it. After partition in the late eighteenth century and the granting of its kingship to the tsar of Russia at the Congress of Vienna, an independent Poland did not exist again until 1918.

7. O. Sitwell, in W. Sickert, *A Free House!*, p. 350, note.

8. Frick Curatorial File.

9. Ibid.

10. A. von Wurzbach, *Niederländisches Künstlerlexikon*, vol. 1, p. 573.

11. Held, *Rembrandt Studies*, p. 59.

THE REMBRANDT RESEARCH PROJECT (PP. 6–12)

1. Much of the information in this chapter comes from interviews conducted in Amsterdam in October 1988.

2. Haak's views are conveyed also in an interview with Ben Kroon printed in *Kroniek van het Rembrandthuis*, 1987, no. 2.

3. A. Wheelock, untitled, unpublished lecture on Rembrandt attributions, given at the National Gallery of Art, Washington, D.C., 1988.

4. B. Berenson, *The Study and Criticism of Italian Art*, ser. 2, p. 114.

5. J. Bruyn et al., *A Corpus of Rembrandt Paintings*, vol. 1, p. xviii. (Hereafter cited as "*Corpus*.")

6. "The Rembrandt Research Project," *The Burlington Magazine*, November 1983, pp. 661–663.

THE MASTER'S REPUTATION (PP. 13–20)

1. Heller's book is *Picture This* (New York, 1988); the science fiction book is *A Different Light* by Elizabeth A. Lynn (New York, 1978).

2. The comments of, respectively, Hilton Kramer, *The New Criterion*,

April 1988; George Steiner, *The New Yorker*, May 30, 1988; and Nicholas Penny, *London Review of Books*, October 27, 1988.

3. G. Schwartz, interviewed by M. Brenson, *The New York Times*, February 28, 1987.

4. W. Sickert, "The Polish Rider," in *The New Age*, June 23, 1910, repr. in *A Free House!*, pp. 161 ff.

5. "Rembrandt's Use of Models and Mirrors," *The Burlington Magazine*, February 1977, pp. 94–98; *Kroniek van het Rembrandthuis*, 1978, no. 1.

6. *The Save Rembrandt Campaigner*, no. 1 (1991).

7. Among the poems *The Polish Rider* has inspired, that by F. Warre Cornish is quoted in full in Held, *Rembrandt Studies*, p. 59. Another, anonymous verse, drawn to my attention by Egbert Haverkamp-Begemann, appeared in *Art in America* in October 1920. I quote from the first stanza:

 Who is this rider of the tasselled steed
 That steps so high and champs the silver bit? . . .
 Is it not Youth upon his charger white,
 All armed with sword and bow, who rides away
 Upon the great adventure that is Life?
 His is the task some ancient wrong to right,
 Some enemy of God and man to slay,
 Or die himself there in the thick of strife!

 Although they are prose works that don't explicitly mention Rembrandt or his art, two novellas in Marguerite Yourcenar's *Two Lives and a Dream* (New York and London, 1987) conjure up brilliantly, and less fancifully, the artist's time and country.

8. G. Schwartz, "Do We Expect Too Much from Rembrandt?," lecture given at the Metropolitan Museum of Art, New York, 1987.

9. Schwartz, *Rembrandt*, p. 305.

10. E. van de Wetering, "Rediscovering Rembrandt," lecture given at the Frick Collection, New York, 1987.

11. K. Clark, *Rembrandt and the Italian Renaissance*, pp. 36–40; C. Bell, *Art* (New York, 1914), p. 118.

12. "Ruskin said of Rembrandt that he was a miser & a Drunkard" (the painter David Roberts, quoted in *Turner Studies*, 9, no. 1 [1989], p. 7). The statue, by Louis Royer, was erected in 1852.

13. S. Schama, *The Embarrassment of Riches*, p. 443.

14. J. Orlers, *Beschrijvinge der Stadt Leyden* (2nd ed., 1641), p. 375.

15. See S. Slive, *Rembrandt and His Critics*, p. 15.

16. R. Schillemans, "Gabriel Bucelinus and 'The Names of the Most Distinguished European Painters,'" *Mercury*, 6 (1987). I thank Egbert Haverkamp-Begemann for drawing my attention to Bucelinus.

QUESTIONS OF IDENTITY (PP. 21–29)

1. Schama, *The Embarrassment of Riches*, p. 240.
2. Clark, *Rembrandt and the Italian Renaissance*, p. 40.
3. K. Clark, *An Introduction to Rembrandt*, pp. 57–60.
4. Clark, *Rembrandt and the Italian Renaissance*, pp. 36–40.
5. A. M. Hind, *Rembrandt*, p. 90.
6. Held, *Rembrandt Studies*, p. 86.
7. Z. Zygulski, quoted in Held, *Rembrandt Studies*, p. 195.
8. Held, ibid., p. 76.
9. C. Campbell, "Rembrandt's 'Polish Rider' and the Prodigal Son," *Journal of the Warburg & Courtauld Institutes*, 33 (1970), p. 300.
10. L. S. Slatkes, *Rembrandt and Persia*, pp. 60–92.
11. Arms and the man: In the inventory of Rembrandt's possessions made in 1656 a number of weapons are listed, including swords, bows, and arrows (e.g., items 312, 313, 315, 319, 339). A translation of the inventory is in Clark, *Rembrandt and the Italian Renaissance*, pp. 193–209. For Baldinucci, see Slive, *Rembrandt and His Critics*, p. 113. For *The Raising of Lazarus*, see Held, *Rembrandt Studies*, p. 76.
12. J. Białostocki, "Rembrandt's 'Eques Polonus,'" in *Oud Holland*, 84 (1969), pp. 163–176.
13. On Jan Makowski, see H. F. Wijnman, "Rembrandt en Hendrick Uylenburgh te Amsterdam," *Amstelodamum*, 43 (1956), pp. 94–103.
14. "Henry Clay Frick," *Dictionary of American Biography*, vol. 7 (New York, London, 1931), pp. 29–31.
15. Białostocki, "Rembrandt's 'Eques Polonus,'" p. 175; Davidson and Munhall, *Paintings of the Frick Collection*, vol. 1, p. 265.
16. B. Broos, "Rembrandt's Portrait of a Pole and His Horse," *Simiolus*, 7, no. 4 (1974), pp. 192–218.
17. Held, *Rembrandt Studies*, p. 198.
18. Ibid., p. 59.
19. Clark, *An Introduction to Rembrandt*, pp. 57–60.
20. M. Rubinstein, *Rembrandt and Angels* (Kent, England, 1982).
21. Campbell, "Rembrandt's 'Polish Rider,'" p. 294.
22. Slatkes, *Rembrandt and Persia*, pp. 84–86.
23. Frick Curatorial File.
24. W. R. Valentiner, "Rembrandt's Conception of Historical Portraiture," *Art Quarterly*, 11 (1948), pp. 116–135.
25. Schwartz, *Rembrandt*, p. 277.
26. P. Sutton, review of Schwartz, *Rembrandt*, *The Burlington Magazine*, September 1986, pp. 681–682.
27. J. Z. Kannegieter, "De Poolse Ruiter," *Kroniek van het Rembrandthuis*, 24 (1970), part 1, pp. 81–84; part 2, pp. 85–87.
28. Schama, *The Embarrassment of Riches*, p. 408.
29. Including Josua Bruyn. However, Mieke Bal, in her 1991 book *Read-*

ing Rembrandt, refers rather to the indeterminate gender of the rider.

30. Clark, *An Introduction to Rembrandt,* pp. 57–60.

31. Among them Georges Mycielski, who said it was "*sans doute*" Titus (see Held, *Rembrandt Studies,* p. 72).

32. Sickert, *A Free House!,* p. 162.

33. R. Fry, *Transformations,* pp. 40–41.

34. Campbell, "Rembrandt's 'Polish Rider,' " p. 302.

35. Clark, *An Introduction to Rembrandt,* p. 60.

36. Held, *Rembrandt Studies,* p. 97. Furthermore, Schwartz, *Rembrandt,* pp. 108 and 118, has drawn attention to a possible link between another Rembrandt, *The Raising of the Cross,* painted for the stadtholder Prince Frederick Henry around 1633, and a poem by John Donne. The poem, "Good Friday, 1614. Riding Westward," along with other Donne poems, had been translated into Dutch by the prince's secretary and Rembrandt's contact in the court, Constantijn Huygens. "Its central image," writes Schwartz, "is of a rider travelling on the day of the Crucifixion in the opposite direction to that in which Christ was facing on the Cross." Schwartz asks if the mounted centurion in *The Raising of the Cross* is that rider. However, he and his horse are standing immobile behind the cross and are not traveling. It would surely make as much sense to ask whether, twenty-some years later, around 1655, Rembrandt might have remembered Donne's lines, written as the poet rode toward Sir Edward Herbert's home in Wales: "Hence is't, that I am carryed towards the West / This day, when my Soules forme bends toward the East."

37. G. Schwartz, *Rembrandt,* p. 328.

CONNOISSEURSHIP (PP. 30–36)

1. Richardson, *Works.* Richardson and his son (and namesake) also wrote a guidebook much used by British travelers on the Grand Tour.

2. Ibid., pp. 243, 270.

3. Ibid., pp. 166–168, 219, 205–206, 218–219, 213, 306–307, 203–204.

4. Ibid., pp. 309, 314, 77, 34, 37.

5. Slive, *Rembrandt and His Critics,* p. 153.

6. Richardson, *Works,* p. 283.

7. *Dr. Johnson by Mrs. Thrale,* ed. R. Ingrams (London, 1984), p. 89. Later (p. 135), Ingrams notes that the phrase first appeared in art in a painting by Guercino (1591–1666).

8. G. Schwartz, "Connoisseurship: The Penalty of Ahistoricism," *The International Journal of Museum Management and Curatorship,* 1988.

9. G. Morelli, *Italian Painters,* vol. 1, p. 32.

10. Ibid., p. 75.

11. R. Wollheim, *On Art and the Mind,* p. 209.

12. Ibid., p. 193.

13. Ibid., p. 196.

14. E. H. Gombrich, *Art and Illusion*, pp. 365–366.

15. S. Freud, *Complete Psychological Works*, vol. 13, pp. 211–236. Carlo Ginzburg, in *Myths, Emblems, Clues* (London, 1990), pp. 96–125, discusses Morelli's influences on Freud and recalls Enrico Castelnuovo's perception of the similarity between Morelli's method and that "ascribed, almost contemporaneously, to Sherlock Holmes by his creator, Arthur Conan Doyle. In the story . . . 'The Cardboard Box,' Holmes says, 'As a medical man, you are aware, Watson, that there is no part of the body which varies so much as the human ear. . . . In last year's Anthropological Journal you will find two short monographs from my pen upon the subject.'" As Ginzburg notes, all three—Freud, Doyle, and Morelli—were medical men by training.

16. B. Berenson, *The Study and Criticism of Italian Art*, ser. 2, pp. iv, 124, 132.

17. Richardson, *Works*, p. 205.

18. Schwartz, "Connoisseurship."

19. Berenson, quoted in H. Hahn, *The Rape of La Belle* (Kansas City, 1946), cited by Schwartz, "Connoisseurship."

SCIENTIFIC ANALYSIS (PP. 37–40)

1. *Corpus*, vol. 1, p. ix.

2. M. Ainsworth et al., *Art and Autoradiography*, pp. 12, 92.

3. Ibid., p. 96.

4. Held, *Rembrandt Studies*, pp. 13–15.

5. S. Walden, "Commentary," *Times Literary Supplement* (London), November 11–17, 1988.

6. *Corpus*, vol. 2, p. 42.

7. D. Bomford, C. Brown, and A. Roy, *Art in the Making: Rembrandt*, p. 16.

REMBRANDT'S SCHOOL (PP. 41–47)

1. Van de Wetering, "Rediscovering Rembrandt."

2. J. C. Van Dyke, *Rembrandt and His School*, p. 4.

3. R. H. Wilenski, *Dutch Painting*, p. 89.

4. Slive, *Rembrandt and His Critics*, p. 27.

5. *Corpus*, vol. 2, p. 45.

6. B. Broos, "Fame Shared Is Fame Doubled," in A. Blankert et al., *The Impact of Genius*, pp. 40–44.

7. Slive, *Rembrandt and His Critics*, p. 52.

8. For further discussion see A. Bailey, *Rembrandt's House*, p. 98.

9. W. Stechow, "The Crisis in Rembrandt Research," in *Art Studies for an Editor: Essays in Honor of Milton S. Fox*, pp. 235–239.

10. Ibid.
11. Schwartz, "Connoisseurship"; *Corpus*, vol. 1, p. 584.
12. Christopher Brown, in his monograph *Carel Fabritius* (Oxford, England, 1981), has drawn attention to several works by Fabritius that were attributed to Rembrandt in the nineteenth century. The French connoisseur Théophile Thoré had a hand in disentangling some of the attributions.
13. J. Białostocki, "Rembrandt and Posterity," *Nederlands Kunsthistorisch Jaarboek*, 1972, pp. 131–157.
14. Van Dyke, *Rembrandt and His School*. Van Dyke thought the *Hendrickje Stoffels* in the Metropolitan was by Barent Fabritius.
15. Held, *Rembrandt Studies*, pp. 10–11.
16. Broos, "Fame Shared," pp. 46–47; he names fifty of Rembrandt's pupils.
17. C. Brown et al., *Rembrandt: The Master and His Workshop*, pp. 384–385. John Van Dyke attributed *The Vision of Daniel* to van den Eeckhout, who seems to me just as likely if one is looking for a Rembrandt-esque follower or, as I would prefer in this case, collaborator.
18. G. Jansen, in Blankert et al., *The Impact of a Genius*, p. 88.

RESTORATIONS (PP. 48–52)

1. E. Fromentin, *The Masters of Past Time*, p. 182. Fromentin apparently was unable to like some of Rembrandt's work but didn't "dare to write down this blasphemy." However, while in Holland in 1875 he wrote to a friend: "Rembrandt doesn't allow me to sleep" (see Białostocki, "Rembrandt and Posterity").
2. See K. Clark, *Ruskin Today*, p. 243.
3. Białostocki, in "Rembrandt and Posterity," quotes a 1920s limerick "ascribed to Riefstahl":

 When the Rembrandt came to the cleaner
 It began to look meaner and meaner.
 Said Rembrandt van Rijn,
 I doubt it is mine,
 Ask Bode or else Valentiner.

4. D. Loercher, "Is 'Restoration' Destroying the Old Masters?," *The Christian Science Monitor*, May 17, 1976.
5. M. Daley, "A Crime Against the Artist," *The Independent* (London), November 22, 1991.
6. Loercher, "Is 'Restoration' Destroying the Old Masters?"
7. Davidson and Munhall, *Paintings of the Frick Collection*, vol. 1, pp. 258–260.
8. Frick Curatorial File.
9. Ibid.
10. Suhr's remarks on Rembrandt's "characteristic technique" have recently been echoed by Leo Stevenson, a present-day copyist of seventeenth-

century Dutch paintings, who writes: "As a painter, I find it embarrassing how such scholars [as those in the RRP] can pass judgment on style, brushwork and draughtsmanship without ever having painted themselves.... To attribute *The Polish Rider* to Drost just shows their lack of understanding of painting as a craft" (*The Independent* [London], April 2, 1992).

11. I am indebted to Elizabeth Hamilton-Eddy, a conservator at the National Maritime Museum, Greenwich, England, for this information.

RUDIMENTS AND DOCUMENTS (PP. 53–55)

1. Berenson, "The Rudiments of Connoisseurship," in *The Study and Criticism of Italian Art*, ser. 2, p. 111.

2. Schwartz, *Rembrandt*, p. 65.

3. N. Goodman, "Art and Authenticity," in *Languages of Art* (Indianapolis, 1968), pp. 100, 116, 119. Goodman also points out (p. 109) that the concern with genuineness should not be confused with consideration of aesthetic merit: an original painting may be less rewarding than an inspired copy, for example, a copy of a Pieter Lastman by his pupil Rembrandt.

4. Schwartz, "Connoisseurship."

SCHOLARS' MISTAKES (PP. 56–59)

1. Schwartz, "Do We Expect Too Much?," pp. 6–7.

2. "A few words cannot do justice to this masterpiece," Rosenberg wrote. "The contrast between the splendour of the helmet and the subdued tonality of the face makes one deeply conscious of both the tangible and the intangible forces in Rembrandt's world.... As in all his greatest works, one feels here a fusion of the real with the visionary" (*Rembrandt: Life and Work*, p. 106).

3. Schwartz, "Do We Expect Too Much?," p. 18.

4. J. Reynolds, "A Journey to Flanders and Holland in the Year 1781," quoted in Slive, *Rembrandt and His Critics*, p. 5.

5. A. Graham-Dixon, "Looking into Rembrandt," *The Independent* (London), September 10, 1988.

6. Learning more about Bourdon: *The Ark of the Covenant* used to belong to Sir Joshua Reynolds, who bequeathed it to the amateur painter and art patron Sir George Beaumont (*The Farington Diary*, vol. 5, p. 76).

A TEAM AND ITS CRITICS (PP. 60–70)

1. *Corpus*, vol. 1, p. xvii.

2. J. F. van Wijnen, "A Genuine Rembrandt, More or Less," *Dutch Heights*, July 1988, p. 16.

3. "The Rembrandt Research Project," p. 662.

4. P. Sutton, review of S. Alpers, *Rembrandt's Enterprise*, *The Burlington Magazine*, June 1989, pp. 428–430.

5. G. Schwartz, review of S. Alpers, *Rembrandt's Enterprise*, *Art in America*, November 1988, pp. 25–29.

6. W. Bode, "The Berlin Renaissance Museum," *The Fortnightly Review*, October 1891, p. 509.

7. Editorial, "The Rembrandt Research Project," *The Burlington Magazine*, November 1983, p. 662.

8. W. Liedtke, "Reconstructing Rembrandt," *Apollo*, May 1989, pp. 330–331.

9. Ibid.

10. S. Alpers, *Rembrandt's Enterprise*, p. 59.

11. A. van der Woude, "The Volume and Value of Paintings in Holland at the Time of the Dutch Republic," in D. Freedberg, ed., *Art in History, History in Art*, pp. 285–329. In the same book (pp. 331–371), John Michael Montias analyzes subjects and attributions of works of art in the more prosperous houses of seventeenth-century Amsterdam and notes that Rembrandt was among the artists whose works were most frequently held in private collections.

12. Schwartz, *Rembrandt*, p. 348.

13. Ibid., p. 363.

14. Ibid., p. 42.

15. Schwartz, "Connoisseurship."

MONDAY MORNINGS (PP. 71–76)

1. C. Brown, in Bomford et al., *Art in the Making*, p. 13.

2. Ainsworth et al., *Art and Autoradiography*, p. 98, n. 28.

3. *Corpus*, vol. 2, pp. 742–750.

4. Liedtke, "Reconstructing Rembrandt," p. 330.

5. Ainsworth et al., *Art and Autoradiography*, p. 29.

6. S. Hochfield, "Rembrandt: The Unvarnished Truth?," *ARTnews*, December 1987, p. 111.

7. Quoted in Wheelock, lecture on Rembrandt attributions.

8. B. Haak, Rembrandt, *His Life, Work, and Times*, pp. 126–127.

9. Liedtke, "Reconstructing Rembrandt," p. 328.

10. J. F. van Wijnen, "A Genuine Rembrandt, More or Less," p. 16.

11. Private letter.

12. Richardson, *Works*, p. 208.

13. E. van de Wetering, in Brown et al., *Rembrandt: The Master and His Workshop*, p. 13.

HANDLING THE NEWS OF REJECTION (PP. 77–82)

1. A. Graham-Dixon, "Finding Knowledge in Lost Rembrandts," *The Independent* (London), December 9, 1989; *Rembrandt*, program by G. Dunlop, BBC 2, March 25, 1992.
2. L. S. Slatkes, review of RRP *Corpus*, vol. 3, *The Journal of Art*, May 1991, p. 73.
3. Blankert et al., *The Impact of a Genius*, p. 32.
4. Schwartz, "Do We Expect Too Much?," p. 18.

THE CASE OF *THE POLISH RIDER* (PP. 83–96)

1. Bruyn, review of Sumowski.
2. S. Hochfield, "Rembrandt—The Unvarnished Truth?," *ARTnews*, December 1987, p. 103.
3. Alpers, *Rembrandt's Enterprise*, ill. 4.35.
4. Brown et al., *Rembrandt: The Master and His Workshop*, p. 119.
5. J. Alsop, "The Faker's Art," *The New York Review of Books*, October 23, 1986. Bruyn protested in a letter to the *Review*.
6. Frick Curatorial File.
7. Alpers, *Rembrandt's Enterprise*, p. 121; *Corpus*, vol. 1, p. xx.
8. The library cloakroom provided dark blue polyester jackets and skirts for readers who arrived improperly garbed.
9. P. Sutton, *Dutch Art in America*, p. 170.
10. Schwartz, *Rembrandt*, p. 278.
11. *Corpus*, vol. 2, p. 45.
12. J. Bruyn, conversation with the author.
13. Van Dyke, *Rembrandt and His School*, p. 60.
14. Bruyn, review of Sumowski.
15. Blankert et al., *The Impact of a Genius*, p. 73.
16. Ibid., p. 29; and see pp. 130–131 for illustration of a Rembrandtesque Drost.
17. J. Rosenberg, S. Slive, and E. H. ter Kuile, *Dutch Art and Architecture, 1600–1800*, p. 98.
18. Liedtke, "Reconstructing Rembrandt," p. 324.
19. W. Sumowski, *Gemälde der Rembrandt-Schüler*.
20. Sickert, *A Free House!*, p. 164. When Sickert visited the Carfax Gallery, where the painting was on display, other members of the public were taking a close look at it, to his annoyance. "The usual ass was there the day I went, angrily measuring the horse's head with his umbrella and muttering calculations as to the interest the money paid for the picture would bring in—as if it had been taken out of his pocket. And the inevitable super-goose was dissatisfied with the horse's legs!"
21. Ainsworth et al., *Art and Autoradiography*, p. 27.
22. Ibid., pp. 72, 99, n. 50.
23. E. van de Wetering, conversation with the author.

24. S. Slive, *Rembrandt and His Critics*, p. 184.
25. Quoted ibid., p. 147.
26. Richardson, *Works*, p. 229.
27. J. Held, *Rembrandt Studies*, p. 83.
28. See note 3 to first chapter.

A MATTER OF EMOTION (PP. 97–100)

1. Schwartz, "Do We Expect Too Much?," p. 13.
2. Schwartz, interviewed by Brenson.
3. E. H. Gombrich, *Meditations on a Hobby Horse*, p. 56. William James, in *The Principles of Psychology* (New York, 1890), writes of "feeling a color" (p. 113) and discusses the bodily changes that follow the perception of an exciting object (pp. 449–450).
4. Richardson, *Works*, p. 266.
5. The *Faust* quotation is from G. G. Coulton, *Art and the Reformation*, p. 483. Coulton goes on: "Rembrandt thus stood face to face with the Gospel narrative; he felt it in many cases more vividly than any medieval artist; and his *Raising of Lazarus*, apart from its purely technical excellences, has all the life and religious feeling of the very best thirteenth century work."
6. Wollheim, *Art and Its Objects*, p. 112.
7. W. Pater, *The Renaissance*, p. 51.
8. Wollheim, *Art and Its Objects*, p. 171.
9. M. J. Friedländer, *On Art and Connoisseurship*, p. 30. In another realm, I. A. Richards has attempted to approach this complex subject in regard to the feelings aroused by poetry (*Practical Criticism*, pp. 196–213). But Richards's consideration of the "sensuous aspects of words" and his analysis of the attributes and interconnections of feelings don't have to assist in the task of attribution—that is, in identifying the authors of poems, who are rarely anonymous.
10. C. R. Leslie, *Memoirs of the Life of John Constable* (London, 1843; repr. 1951), p. 237. It should be noted that on another occasion Constable said, "Painting is a Science and should be pursued as an enquiry into the Laws of Nature" (p. 323).
11. H. van Os, "I Hate Rembrandt," *The Art Newspaper*, December 1991, pp. 11–12.
12. B. Berenson, *Lorenzo Lotto*, p. 250. In her biography of Berenson, Meryle Secrest quotes the Quattrocento expert Creighton Gilbert: "Attributions are really only hunches.... While on the one hand they are matters of feeling, they are also ego-trips (it's pretty wonderful to be able to say with assurance what an artist did and didn't do) and so there tends to be violent reaction to a denial of somebody's attribution" (*Being Bernard Berenson*, p. 251).
13. H. Wölfflin, *Principles of Art History*, pp. 10, 9.

14. Fry, *Transformations*, p. 54.
15. Van de Wetering, in *Corpus*, vol. 2, p. 60.
16. Schwartz, *Rembrandt*, pp. 364, 278.

THE ARTIST'S IMAGE AND THE ARTIST'S TIME (PP. 101–108)

1. "The Rembrandt Research Project," p. 662.
2. Schwartz, *Rembrandt*, p. 370, note to p. 255.
3. Brown, in Bomford et al., *Art in the Making*, p. 21.
4. Schwartz, *Rembrandt*, p. 358.
5. N. Penny, "Gestures of Embrace," review of S. Alpers, *Rembrandt's Enterprise, London Review of Books*, October 27, 1988.
6. Brown, in Bomford et al., *Art in the Making*, p. 58.
7. Schwartz, *Rembrandt*, p. 349.
8. J. A. Emmens, cited by E. de Jongh, "The Spur of Wit: Rembrandt's Response to an Italian Challenge," *Delta*, Summer 1969, p. 49.
9. H. Gerson, "Rembrandt and the Spanish Baroque," *Delta*, Summer 1969, p. 8.
10. Wölfflin, *Principles of Art History*, p. 216.
11. Fromentin, *Masters of Past Time*, p. 230.
12. Liedtke, "Reconstructing Rembrandt," p. 328.
13. Clark, *An Introduction to Rembrandt*, pp. 57–60.
14. The works mentioned here are in, respectively: the Louvre, Paris (the *Ox* and the *Bathsheba*); the Museum Boymans–van Beuningen, Rotterdam; the National Gallery, Washington; the Six Collection, Amsterdam; the National Gallery, London; the Rijksmuseum, Amsterdam; and the Staatliche Gemäldegalerie, Kassel Germany (the *Jacob* and the landscape). The two drawings, Slive 525 and 95, respectively, are in the British Museum, London, and the Rembrandthuis, Amsterdam.
15. Van de Wetering, "Rediscovering Rembrandt."
16. *Corpus*, vol. 2, p. 96, n. 37.
17. These bursts of intolerance were not confined to the Calvinists; the Jewish philosopher Baruch Spinoza was excommunicated for his opinions by his synagogue in 1656.
18. For more on this period and Rembrandt's financial problems, see W. L. Strauss and M. van der Meulen, eds., *The Rembrandt Documents*, and Bailey, *Rembrandt's House*.
19. J. Huizinga, *Dutch Civilization in the Seventeenth Century*, p. 101.
20. B. Willey, *The Seventeenth Century Background*, p. 51.
21. Schama, *The Embarrassment of Riches*, pp. 338, 568.
22. Clark, *Rembrandt and the Italian Renaissance*, p. 206 (inventory no. 305).
23. N. Pevsner, *Academies of Art* (Cambridge, England, 1940), p. 129.

UNANSWERED QUESTIONS (PP. 109–113)

1. Wheelock, Kitson, Freedberg, Bruyn, conversations with the author.
2. *Rembrandt*, program by Dunlop.
3. R. Gimpel, *Diary of an Art Dealer*, pp. 95–96.
4. In his life of Henry Clay Frick, George Harvey records that late in life, when asked what man's gifts he would have chosen, could they have been his, the magnate replied without hesitation: "Rembrandt's" (*Henry Clay Frick, the Man*, p. 336).

Bibliography

Ainsworth, Maryan, et al. *Art and Autoradiography.* New York, 1982.

Alpers, Svetlana. *Rembrandt's Enterprise.* Chicago and London, 1988.

Alsop, Joseph. "The Faker's Art," *The New York Review of Books,* October 23, 1986.

Bailey, Anthony. *Rembrandt's House.* Boston and London, 1978.

Berenson, Bernard. *Lorenzo Lotto.* London, 1901.

———. *The Study and Criticism of Italian Art,* ser. 2. London, 1902.

Białostocki, Jan. "Rembrandt and Posterity," *Nederlands Kunsthistorisch Jaarboek,* 1972, pp. 131–157.

———. "Rembrandt's 'Eques Polonus,'" *Oud Holland,* 84 (1969), pp. 163–176.

Blankert, Albert, Ben Broos, Ernst van de Wetering, et al. *The Impact of a Genius.* Amsterdam, 1983.

Bomford, David, Christopher Brown, and Ashok Roy. *Art in the Making: Rembrandt.* London, 1988.

Bredius, Abraham. *Rembrandt: The Complete Edition of the Paintings,* rev. Horst Gerson. London, 1969.

Broos, Ben. "Rembrandt's Portrait of a Pole and His Horse," *Simiolus*, 7, no. 4 (1974), pp. 192–218.

Brown, Christopher, et al. *Rembrandt: The Master and His Workshop.* New Haven, CT, and London, 1991.

Bruyn, Josua. Review of *Gemälde der Rembrandt-Schüler* by Werner Sumowski, *Oud Holland*, 98 (1984).

———, B. Haak, S. H. Levie, P. J. J. van Thiel, and E. van de Wetering. *A Corpus of Rembrandt Paintings*, 3 vols. The Hague, 1982, 1986, 1989.

Bunting, Madeleine. "Blood on the Canvas," *The Guardian* (London), July 26, 1991.

Campbell, Colin. "Rembrandt's 'Polish Rider' and the Prodigal Son," *Journal of the Warburg and Courtauld Institutes*, 33 (1970), pp. 292–303.

Ciechanowiecki, Andrew. "Notes on the Ownership of *The Polish Rider*," *The Art Bulletin*, 42 (1960), pp. 294–296.

Clark, Kenneth. *An Introduction to Rembrandt.* London, 1978.

———. *Rembrandt and the Italian Renaissance.* New York, 1968.

———. *Ruskin Today.* London, 1964.

Coulton, G. G. *Art and the Reformation*, 2nd ed. Cambridge, England, 1953.

Davidson, Bernice, and Edgar Munhall. *Paintings of the Frick Collection: An Illustrated Catalogue*, vol. 1. New York, 1968.

de Jongh, Ed. "The Spur of Wit: Rembrandt's Response to an Italian Challenge," *Delta*, Summer 1969.

Freedberg, David, ed. *Art in History, History in Art.* Chicago, 1991.

Freud, Sigmund. "The *Moses* of Michelangelo," in *Complete Psychological Works*, vol. 13. London, 1964.

Friedländer, Max J. *On Art and Connoisseurship.* London, 1943.

Fromentin, Eugène. *Masters of Past Time*, ed. Horst Gerson. London, 1948.

Fry, Roger. *Transformations.* London, 1926; repr. New York, 1956.

Gerson, Horst. "Rembrandt and the Spanish Baroque," *Delta*, Summer 1969.

Gimpel, René. *Diary of an Art Dealer.* New York, 1966.

Gombrich, E. H. *Art and Illusion.* London and New York, 1960.

———. *Meditations on a Hobby Horse.* London, 1963.

Graham-Dixon, Andrew. "Looking into Rembrandt" and "Finding Knowledge in Lost Rembrandts," *The Independent* (London), September 10, 1988, and December 9, 1989.

Haak, Bob. *Rembrandt, His Life, Work, and Times.* New York and London, 1969.

Harvey, George. *Henry Clay Frick, the Man.* New York, 1936.

Held, Julius S. *Rembrandt Studies* (rev. ed. of *Rembrandt's Aristotle*). Princeton, NJ, 1991.

———. *Rembrandt's Aristotle and Other Rembrandt Studies.* Princeton, NJ, 1969.

————. "Rembrandt's 'Polish Rider,'" *The Art Bulletin*, 26 (1944).

Hind, A. M. *Rembrandt*. Cambridge, MA, 1932.

Hochfield, Sylvia. "Rembrandt—The Unvarnished Truth," *ARTnews*, December 1987.

Huizinga, Johan. *Dutch Civilization in the Seventeenth Century*. London and New York, 1968.

Konstam, Nigel. "Rembrandt's Use of Models and Mirrors," *The Burlington Magazine*, February 1977, pp. 94–98.

Kroon, Ben. Interview with Bob Haak, *Kroniek van het Rembrandthuis*, 1987, no. 2, pp. 1–17.

Liedtke, Walter. "Reconstructing Rembrandt," *Apollo*, May 1989.

Morelli, Giovanni. *Italian Painters*. London, 1892–1893.

Pater, Walter. *The Renaissance*. London, 1873.

"The Rembrandt Research Project" (editorial), *The Burlington Magazine*, November 1983, pp. 661–663.

Richards, I. A. *Practical Criticism*. London, 1929.

Richardson, Jonathan. *Works*, ed. J. Richardson, Jr. London, 1773.

Rosenberg, Jakob. *Rembrandt: Life and Work* (2nd ed.). Oxford, England, 1964.

————, Seymour Slive, and E. H. ter Kuile. *Dutch Art and Architecture 1600–1800*. Harmondsworth, England, 1966.

Schama, Simon. *The Embarrassment of Riches*. New York and London, 1988.

Schwartz, Gary. "Connoisseurship: The Penalty of Ahistoricism," *The International Journal of Museum Management and Curatorship*, 1988.

————. "Do We Expect Too Much from Rembrandt?" Lecture given at the Metropolitan Museum of Art, New York, 1987.

————. *Rembrandt, His Life, His Paintings*. Harmondsworth, England, and New York, 1985.

————. Article on the RRP, *The Journal of Art*, September 1991, pp. 47–48.

————. Review of *Rembrandt's Enterprise* by Svetlana Alpers, *Art in America*, November 1988, pp. 25–29.

Secrest, Meryle. *Being Bernard Berenson*. London, 1980.

Sickert, Walter. *A Free House!*, ed. Osbert Sitwell. London, 1947.

Slatkes, Leonard S. *Rembrandt and Persia*. New York, 1983.

————. Review of RRP *Corpus*, vol. 3, *The Journal of Art*, May 1991, p. 73.

Slive, Seymour. *The Drawings of Rembrandt*, 2 vols. New York, 1963.

————. *Rembrandt and His Critics*. The Hague, 1953.

Stechow, Wolfgang. "The Crisis in Rembrandt Research," in *Art Studies for an Editor: Essays in Honor of Milton S. Fox*. New York, 1975.

Strauss, W. L., and M. van der Meulen, eds. *The Rembrandt Documents*. New York, 1979.

Sumowski, Werner. *Gemälde der Rembrandt-Schüler*, 5 vols. Landau, Germany, 1983–1990.

Sutton, Peter. Review of *Rembrandt, His Life, His Paintings* by Gary Schwartz, *The Burlington Magazine*, September 1986, pp. 680–681.

Van Dyke, John C. *Rembrandt and His School.* New York, 1923.

van Wijnen, Jan Fred. "A Genuine Rembrandt, More or Less," *Dutch Heights*, July 1988.

von Wurzbach, Alfred. *Niederländisches Künstlerlexikon.* Vienna, 1906.

Wheelock, Arthur. Untitled, unpublished lecture on Rembrandt attributions, given at the National Gallery of Art, Washington, D.C., 1988.

White, Christopher. *Rembrandt and His World.* London, 1964.

Wilenski, R. H. *Dutch Painting* (rev. ed.). London, 1955.

Willey, Basil. *The Seventeenth Century Background.* London, 1934; New York, 1953.

Wölfflin, Heinrich. *Principles of Art History* (1914). New York, 1956.

Wollheim, Richard. *Art and Its Objects* (2d ed.). Cambridge, England, 1980.

——. *On Art and the Mind.* London, 1973.

Woolf, Virginia. *Roger Fry, Painter and Critic.* London, 1940.

List of Illustrations

9. Stefano della Bella. *Polish Horsemen*, 1650s. Etching. (The Metropolitan Museum of Art, New York, The Elisha Whittelsey Collection, 1967)

10. Albrecht Dürer. *Knight, Death, and the Devil*, 1513. Engraving. (The Metropolitan Museum of Art, New York, Harris Brisbane Dick Fund, 1943)

11. Lucas Cranach. *A Saxon Prince on Horseback*, 1506. Woodcut. (The Metropolitan Museum of Art, New York, Rogers Fund, 1918)

12. Abraham de Bruyne. *Der Poolsche Reyter*, 1617. Engraving. (The Metropolitan Museum of Art, New York, The Elisha Whittelsey Collection, 1951)

13. Rembrandt. *Joseph Accused by Potiphar's Wife*, 1655. Oil on canvas. (National Gallery, Washington, D.C., Andrew W. Mellon Collection)

14. Rembrandt. *Titus at His Desk*, 1655. Oil on canvas. (Museum Boymans–van Beuningen, Rotterdam)

15. Pupil of Rembrandt. *Life Class Drawing a Female Nude*. Drawing. (Hessisches Landesmuseum, Darmstadt, Germany)

16. Rembrandt. *Portrait of a Man*, 1632. Oil on canvas. (The Metropolitan Museum of Art, New York, The H. O. Havemeyer Collection)

17. Rembrandt (or pupil?). *Drawing of a Child*. (Museum het Rembrandthuis, Amsterdam)

18. Willem Drost. *Bathsheba Reading David's Letter*, 1654. Oil on canvas. (Musée du Louvre, Paris)

19. Willem Drost. *Portrait of a Young Woman*. Oil on canvas. (Wallace Collection, London)

20. Rembrandt. *Portrait of Jan Six*, 1654. Oil on canvas. (Six Collection, Amsterdam)

21. Rembrandt. *Landscape with Rest on the Flight into Egypt*, 1647. Oil on panel. (National Gallery, Dublin)

22. Rembrandt. *Christ Returning from the Temple with His Parents*, 1654. Etching and drypoint. (The Metropolitan Museum of Art, New York, The H. O. Havemeyer Collection)

23. Rembrandt. *The Jewish Bride*, c. 1655. Oil on canvas. (Rijksmuseum, Amsterdam)

24. Rembrandt. *The Artist in His Studio*, c. 1629. Oil on panel. (Museum of Fine Arts, Boston, Zoe Oliver Sherman Collection)

Index